lightkeeper

A Memoir Through the Lens of Love and Loss

Stacy Waldman Bass

RADIUS BOOK GROUP
New York

Radius Book Group
A Division of Diversion Media and Communications, LLC
www.RadiusBookGroup.com

Copyright © 2025 by Stacy Waldman Bass

Duane Michals, *This Photograph Is My Proof*, 1974. © Duane Michals. Courtesy of DC Moore Gallery, New York.

"Ghost Train." Words and music by Marc Cohn. © 1991 Sony Music Publishing (US) LLC. All rights administered by Sony Music Publishing (US) LLC, 424 Church Street, Nashville, TN 37219. International copyright secured. All rights reserved. Reprinted by permission of Hal Leonard LLC.

Phil Greitzer. *Beatles Fans at Kennedy Airport*. February 7, 1964. *New York Daily News Archive* via Getty Images. Reprinted with permission.

All rights reserved, including the right to reproduce this book or portions thereof in any form whatsoever. No part of this publication may be reproduced or transmitted in any form or by any means, electronic or mechanical, including photocopying, recording, or any other information storage and retrieval, without the written permission of the author.

For more information, email info@radiusbookgroup.com.

First edition: September 2025
Hardcover ISBN: 979-8-89515-056-6
eBook ISBN: 979-8-89515-075-7

Manufactured in the United States of America

10 9 8 7 6 5 4 3 2 1

Cover photographs by Stacy Bass and Robert Selverstone
Cover design by Pete Garceau
Interior design by Scribe Inc.

Radius Book Group and the Radius Book Group colophon are registered trademarks of Radius Book Group, a Division of Diversion Media and Communications, LLC.

This book contains the opinions and ideas of the author. There is no business, financial, legal, governance or other professional advice or services offered. The comments, suggestions and strategies that follow may not be suitable for every individual, situation or company and are not warranted or guaranteed to produce any particular results.

For my parents,
Michael Howard Waldman
and
Jessica Friedman Waldman,
with unending gratitude
that you were mine

For it's our grief that gives us our gratitude,
Shows us how to find hope, if we ever lose it.
So ensure that this ache wasn't endured in vain:
Do not ignore the pain. Give it purpose. Use it.

—Amanda Gorman, *The Miracle of Morning*

contents

preface . ix

the day everything changed . 1

beginnings and endings . 7

the space in between . 13

coming home . 17

raisins (in the sun) . 23

daddy's girl . 27

all is forgiven . 31

the minnybus . 35

in the fast lane . 39

poison ivy . 43

men at work . 45

la moubra . 49

the big w . 53

the graduate . 59

boys to men . 61

my forever valentine . 65

sex education . 67

luck of the irish . 71

ashes to ashes . 75

by the sea . 79

oh, deer . 83

beatlemania . 87

mr. newman . 91

contents

walking in memphis . 95

windsurfing . 99

north avenue . 103

i'm getting my act together . 111

the *tortoise* . 115

sugarbush . 119

birchmont babe . 123

fireflies . 127

green grapes . 129

college days . 131

home, again . 133

moving up . 137

block island . 141

take flight . 149

the personals . 153

national hall . 159

food diary . 167

what's in a name? . 171

(un)happy new year . 177

i love you, mom . 183

which would you rather? . 185

broadway baby . 189

i love you, mom—july 20, 2018 . 193

the sweetest sound . 195

bright lights, big city . 201

long goodbye . 205

a living tribute . 209

contents vii

center stage . 213

i love you, mom—july 12, 2019 . 219

i love you, mom—january 12, 2021 . 221

looking forward, looking back . 225

photographs . 229

afterword . 233

acknowledgments . 239

preface

I'm afraid I am beginning to forget.

I always thought I had a great memory. I remember lots of things with little meaning. Like my childhood home phone number: 226-6634. And the number for my private line from my teenage years: 226-9889. The strawberry yogurt pie that my mom always made and how delicious it was a day later, after it started to decompose a bit. How the graham cracker crust absorbed all that flavor to create a thick and creamy paste I found irresistible.

I also remember little things with lots of meaning. What it felt like when my ten-year-old camp boyfriend, Kenny Salk, put his arm around me during a screening of *Star Wars* on a humid, rainy day in July in Wolfeboro, New Hampshire. How the fragrance from the lilac trees in our yard made me feel safe. The sensational electricity that coursed through my entire body when I held my husband Howie's hand for the first time. These memories are broad and deep and teeming with life—overflowing with emotion and punctuated with rich detail.

When I was a freshman in college, I took Psych 101. One day in the enormous and packed lecture hall, the professor asked students to volunteer their earliest memories. Emboldened, I raised my hand and recalled my first birthday. My Uncle Sid, who then worked as a furrier, brought me a tiny, white fur jacket as a gift. I opened my presents in my grandparents' den while I sat on a delicate, pink upholstered rocking chair with white wire detailing. The professor audibly chuckled as I described the memory. He assured me (and the rest of the class) that this was impossible and that I only *thought* I remembered that moment. I had no doubt seen a photograph, he conjectured, that I now confused as a memory. And most assuredly, he was right.

I realized then how vital photographs are and will always be in reconstructing and reinforcing our memories. That moment also gave me a glimpse into how lost I might feel without those images to draw on. I am sure I didn't realize it then, but this formative experience led to my eventual passion

preface

and profession as a photographer. Making photographs—moments frozen in time—has become indispensable to who I am.

Still, I am afraid I am beginning to forget.

I can access the photographs in my scrapbooks and the slides stacked in the old Kodak carousel that highlight slices (slivers, really) of my life, but so much is falling away now. I can't really remember the sound of Dad's voice or his occasional and subtle lisp anymore. The intonation and cadence are there, though dissolving, but the sound, the tone, the timbre—they're largely gone. My grief only compounds the sense of urgency I feel when searching or grasping for a memory. They have become all the more crucial because I don't get to make new memories with Mom or Dad.

I now realize that photographs are merely starting points. Not proof per se, but a portal into the memory itself, which is refracted even more by the relationships they chronicle and the life that existed outside their borders. Maybe words can fill in and expound upon the pixels just outside the frame? Maybe a book like this can breathe new life into old photos and reconstruct the multidimensional beings who were captured and flattened, for an instant, under the sheen of the photographic paper?

In my early twenties, I aspired not to "take" pictures but to "make" them, to examine all that lay beneath them. Susan Sontag's words from *On Photography* filled my mind: "The photographer was thought to be an acute but non-interfering observer—a scribe, not a poet. But as people quickly discovered that nobody takes the same picture of the same thing, the supposition that cameras furnish an impersonal objective image yielded to the fact that photographs are evidence not only of what's there but of what an individual (his/her mind and his/her eyes) sees; not just a record of the world but an evaluation of [it]."

As a newbie photographer and an even newer intellectual, I was both fascinated and obsessed with the artist Duane Michals's work. I was particularly interested in one of his images and how it rightly called into question what we have come to believe—merely because the photograph gently, even unnoticeably, compelled us to.

This photograph is my proof. Or is it?

preface

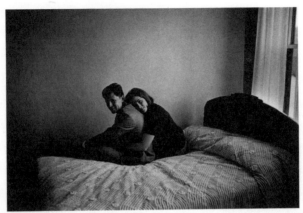

Beneath the image, Michals has written the words, "This photograph is my proof. There was that afternoon, when things were still good between us, and she embraced me, and we were so happy. It had happened. She did love me. Look, see for yourself!"

This narrative suggests a broader story, or at least one that is decidedly more complex. That the relationship depicted in the image has evolved, is evolving. I always interpreted his command to "Look see for yourself!" as a reminder that the picture is a starting point—and even an invitation to look deeper—but it isn't *everything*.

The connection between images and memory has been a through line in my life and in my work as an artist, too. I always had a hard time parting with pictures or pages from a magazine I'd saved that portrayed something I was inspired by or drawn to. They were fragments of a larger story that were meant to remind me: look into this; learn more; explore. And so, perhaps it follows that I became the de facto family archivist, faithfully saving, nurturing, and sharing these discrete captured moments.

Protecting the memories of those I've lost.

What you are about to read is the truth. My truth. My story. Or at least a critically important and central part of it. I've mined my memory in an effort to both illuminate and hold tight to the essence that was my father, Michael Howard Waldman, and my mother, Jessica Friedman Waldman. This is my attempt at memorializing the unique and wholly spectacular relationships I was fortunate to have with each of them.

This book is about love. And also loss. It's about grief and growing. It's about what it means to be a daughter and a parent and to celebrate and elevate those relationships in your life. It's about the act of keeping the light, *their* light, and the light of family and legacy—what I call "lightkeeping," if you will—and how there can be astonishing meaning and power in doing so.

As an artist and photographer, I've looked inward and tried to harness my creativity to reimagine, diffuse, and process the still gripping grief I have carried since my dad died in a tragic accident in 1995. It's been an enormous challenge to manage the constant and unsettling aftershocks felt in my daily life. My 2008 photographic series, *Speak Memory*, explored the complexity, depth, and emotion of memory. By juxtaposing color, text, slices of light, and stream-of-consciousness imagery, this body of work sought to expose personal history and truth and the dreamlike states they often take in one's mind. The saturation, depth, and luminance of memory reverberated through each layer and montage, offering the viewer a sense of hope and discovery.

Similarly, when I embarked on writing this book more than fifteen years ago, I was still searching for relief. For a long time, the writing was intermittent and inconsistent, but when the words came, they served their purpose, and mightily so. During those bursts of writing, I'd allow myself to dip back down into the depths of the missing and the longing. And then, several times a year, on birthdays or anniversaries, I'd sometimes share excerpts of my writing on social media. I found the reaction and support for that still raw and exposing expression to be staggeringly helpful. And so, I continued to reveal

my struggles, access my memories, and write my truth as it came to me, out of order, with no chronology. Deeply felt but disconnected. Clear as day and also hard to discern. In shades of gray or sometimes in full-blown Technicolor. Unnerving, encouraging, long ago tucked away. So very beautiful. Often inspired by a photograph rediscovered or by a brief, evocative moment, scent, or taste that unlocked countless memories.

Over time, and then with my mother's death in 2019, I began to see how essential and fortifying it can be to examine the world outside the frame of the images in my archives—both as a way of exploring and sometimes reconstituting my memories and also very much as a way of cherishing, honoring, and shining light on my parents' lives.

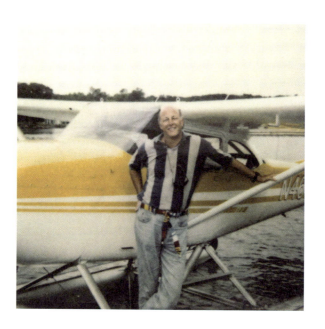

the day everything changed

It's August 26, 1995. It's an astonishingly beautiful day. The sky looks as though it is filled with promise and possibility. I am lying on an oversized green-and-white-striped chaise longue that floats like a beckoning oasis on my parents' Surf Road patio, drawing in would-be recliners like a magnet. The chaise is perfectly placed to admire the changing seasons reflected in the nearby marshes of Westport, Connecticut, and the Long Island Sound. Dad and I were delighted when we first found the chaise at R&R Pool and Patio a few months back. Everybody wanted to sit on it—to the exclusion of at least eight totally acceptable alternatives. I teased him that we clearly needed to get a second one. After a little coaxing, that's exactly what we did.

It's early in the morning, and Dad, my (still new) husband Dan, and my cousin Glenn are sitting on the patio discussing Glenn's future—his job prospects and the bidding war that two employers are waging for his yet-to-be-discovered investment banking prowess. We talk about his charm, wit, dedication, and brilliance. Dan and I have some errands to do, and so we decline Dad's invitation to join him on the seaplane to pick up Darcy, Glenn's older sister, in the Hamptons. She's there spending the weekend with friends. Apparently, a rash of fires there has closed roads and stranded her in immobile traffic. My dad's older sister, always known to me as Auntie Ann, asked Dad if he might go retrieve Darcy. He was more than happy to accept the assignment. In the end, Glenn and his friend Leo, eager for the adventure, decide to go for the ride with Dad.

As it happens, it is also Ann's birthday, and she is hoping to celebrate with the family before our upcoming departure. My mom, Darcy, Auntie Ann, and I are scheduled to leave the next morning for a week at the Golden Door, a tony spa in California that has become one of Mom's favorite retreats. We have never traveled just the four of us on a girls-only trip and are very excited about it. Darcy has called me at regular intervals over the past year, teasing that she couldn't possibly wait until August to go. Couldn't it just be sooner?

I'd smile and remind her that it would be worth the wait; the more stress we'd endure, the more grateful we'd be for the reward of relaxation.

Eventually, Dad leaves to prepare the plane, which is docked just behind the house at the end of a long pier on the shores of Bermuda Lagoon. He returns a while later with his now-familiar preflight jubilation. The serenity and challenge of flying have enchanted him for years. The rush. The thrill. The peace. The joy. The limitless quiet up there in the sky. It is another perfect day for flying. Calm winds. Excellent visibility. And he couldn't be more enthusiastic about the mission to bring Darcy back home.

Before they taxi out of the channel and take off for the Hamptons, Dan and I depart for our day of errands. We've been looking for houses to buy and have already had several false starts, making offers on places that seemed right but just weren't meant to be. At around 1:30 in the afternoon, we are sitting in our blue Honda Accord in a deli parking lot in neighboring Wilton. I'm talking about passion and how vital it is to my sense of self and my sense of being—how important it is to pursue passion, fill up your heart, and embrace life, to feel connected and happy and whole.

Dan looks back at me with a blank stare. What am I saying? Where did all this come from? When did I become unhappy with our marriage? Has something shifted dramatically without warning? While I have been feeling disengaged from our marriage as of late, I avoid having this conversation with him. Not yet. Somehow, things seem to be crystallizing in my mind. I've felt myself going through the motions of young married life, looking for the home in which we would raise our "someday" family. But I've also felt oddly disconnected from myself, as if I'm watching from the outside and perhaps subconsciously trying to find a way to interrupt the momentum and change course. I'm feeling a profound sadness—as if I've found myself in a place I never intended to be with a perfectly lovely man who, unfortunately, is just not the right person.

I decide then that it is time to talk to my dad about how I've been feeling. I imagine that he will be especially understanding and sympathetic given his long-ago professed uncertainty about Dan, but I'm also reluctant. I feel partially embarrassed that things are turning out to be as he had surmised they

the day everything changed 3

would be. I want to avoid an admonishing "I told you so," even if he would never verbalize it exactly like that.

Later, we get back to the house, and I am lying alone on the chaise longue waiting for Dad to come home. I feel an urgency to speak with him about what I've been feeling about my marriage. It's 4:00 p.m., and he's late. The August sun is still shining above, but the blue of the sky seems to have shifted. It's less of a happy, jubilant blue and more muted. Maybe the sky knows something we don't? The air feels both warm and cool on my skin, thanks to an intermittent breeze tickling the tops of the billowy sea grasses nearby. I'm listening to my favorite Marc Cohn CD in my headphones, and he is soulfully serenading me. "Everyone talks about some fateful day and I guess that this was mine. . . ." As the music and the message fills my head, I stare out at the sound, searching the sky. It is empty save for its color. Clear and cloudless.

And then time slows. Suddenly, I'm weighed down and overtaken by a muffled and gelatinous parallel universe where nothing will ever be the same. In my peripheral vision, I see Dan struggling to open the heavy glass sliding doors. Even now, almost thirty years later, I can picture his expression with bizarre precision—a confounding mix of terror and joy? OK, maybe not joy, but some kind of subdued glee. It's as if something unspeakable has happened, and while it's not something he would ever have dared wish for, deep down it is hard for him to contain that this twist of events might benefit him in the end. That's what I see. Maybe that's unfair. Inaccurate. It probably is. And yet, in that very moment—the irreversible moment—he delivers the news that there has been a terrible accident. Dad's plane has crashed. My father and my cousins—*my FATHER, my COUSINS*—are dead. *THEY. ARE. DEAD.* There is no turning back. This horrendous, life-altering, indelible moment is forever etched in my mind. For better or worse.

I am lying on the cold terracotta floor at Auntie Ann and Uncle Sid's house only a couple of miles down the road. Adrenaline pumping. Mental chaos. Excruciating pain. I hear everything and nothing. My senses are alive yet numb. Images are racing through my head but are hard to discern. I hear my aunt wailing, crippled with agony and disbelief. I see my uncle shaking, disfigured by uncontrollable convulsions. There is a dull but constant buzzing

in the air. Phones ring, dissonantly and constantly, like a telethon switchboard. People come. People go. Nobody knows what to say. There is nothing to say. I am in a trance. I am waiting for someone to tell me it's all a mistake. My mother is pacing. Her face is distorted, frozen mid-scream. She fights to stay in control. Whispers of blame flit about like a hummingbird. Time is suspended.

The days and weeks that follow collapse into one another. The outline formed by increments of time doesn't make sense and the connections are tenuous. Fragile. There is no order. There is *dis*order. But there are small moments where the memory has fully formed, congealed, and stayed intact. And because those memories are unmistakably real, they're also the most crippling. Undeniable.

I am lying in bed in my old room at Surf Road. The room is dark, but I can see the edge of daylight drawing a squiggly line around the bottom of the shades. The world outside is alive and bright even though I am dying inside. I try to see a path forward, out of this room, out of my mind, but I am lost.

People continue to descend on my aunt and uncle's house, quietly but anxiously waiting to be there to offer aid or comfort. People are coming to my mom's house, too, but noticeably less so. I can feel the chasm between our family splinter further, this unfathomable crevasse deepening with each breath. *Their* loss. *Our* loss. The worst possible scenario. Unimaginable. Countless questions. No answers.

I am sitting on the stone steps outside the house. My therapist has heard the news and has called to see how I am. My voice is almost inaudible, its sound dampened by the inexorable pain that is far from abating. I try to articulate the sensation I have, the feeling that everything is new now. I feel as if I have to relearn every. Single. Thing. What does a strawberry taste like in this new world? What music will soothe me? How could this possibly have happened? And will I ever understand why?

beginnings and endings

I was born at 1:28 a.m. on October 31, 1966. Very early Halloween morning. After an already eighteen-hour labor, my mom was especially determined to give birth before midnight to spare me a lifetime of trick-or-treat jokes, but that wasn't in the cards. As it turns out, sharing a birthday with a candy- and dress-up-focused holiday is actually pretty great. In all the years between then and August 26, 1995, it wouldn't have been hyperbolic to say that life for me, and for the Waldmans, was about as good as it gets. Of course, I had my share of challenges and growing pains, especially as I made my way through my twenties. All things considered, I had everything to be grateful for and not too much to complain about. And I truly felt that way every day.

I had a loving and supportive family. My parents, Michael and Jessica Waldman, were Queens College sweethearts and had a warm and wonderful marriage. They had just celebrated their thirtieth wedding anniversary. My brother, David, was three years my junior. We had overcome some of our childhood skirmishes and nurtured a mutually supportive relationship.

We were extremely close to our extended family, namely the Weiners: Auntie Ann and Uncle Sid and their kids, Darcy and Glenn, who were each in their twenties by then. Along with my paternal grandparents, Enoch (Eddie) and Leah Waldman, we counted ourselves beyond lucky to spend so much time together. By choice.

I had a reliable and truly wonderful collection of friends. And always, always, an abundance of love. I was afforded every advantage in my upbringing: Westport was a safe and beautiful place to grow up in; I had countless opportunities to travel and learn; and I also got the chance to go to an excellent college and then law school. I was newly married to Dan, whom I'd met while in law school, and I had just started an amazing job working at Savoy Pictures Entertainment, a new movie studio based in New York City that was founded by Victor Kaufman, one of my professors at NYU Law. Life was good.

My grandmother Leah used to say that things were just too good before the accident. "We were living as if on a cloud," floating effortlessly and free, and the universe set out to balance the scale.

Not long after the accident, Dan and I separated and then divorced. Only three and a half short years after our wedding day. It might seem crazy to say this, but the way he delivered the news of the accident irrevocably connected him to that moment for me—and in the worst way. That and the temporary suspension of my reality and normal functioning—owing to the accident—were too potent a concoction to heal the rift that had opened between us. There was just no going back.

The accident altered the cadence of life for me. It created an imperativeness I hadn't expected. The rules had changed. It was no longer possible for me to discount some of the misgivings Dad had vocalized about my marriage before he died. In fact, in Dad's absence, his comments reverberated ever more forcefully in my mind, growing louder and louder each day.

I've since rationalized our divorce. I figure that if the marriage was meant to be, if Dan was my forever person and the future father of my future children, then perhaps we would have or could have survived. But at that time and in those acutely fragile moments, the ocean of loss just swallowed me whole.

The period just after the accident felt endless and undelineated. All regular time intervals—minutes, hours, days, weeks—ceased to exist. Our new reality hung in the air, heavy and horrible, like purgatory. My family held a memorial in the backyard at Surf Road, mere feet from where I had been sitting when Dan shared the news. While many people came to offer condolences, I made it through the day by disconnecting from the goings-on; it was as if I was hovering from above, watching myself go through the motions. Like a ghost. Fully outside of my body. And out of my mind.

Ann and Sid, and many of our family's mutual friends, didn't attend the service. We were told they just couldn't. But we knew what that really meant. The searing pain and fuming hatred—and yes, the blame, too—were all-consuming.

One of Dad's dearest friends, Bob Selverstone, spoke at the memorial about "the most unforgettable character he's ever known." He called Dad "the straw that stirred the drink" and honored him with spectacular clarity

beginnings and endings 9

and generosity. He eulogized Dad's relentless, sometimes maddening, passion for work and play; his fierce devotion to his family; and the exquisite peacefulness he found whenever he was on the water. Or up in the sky. He also shared that Dad could be incessantly challenging—sometimes pushing people outside of their comfort zones. Determined, even sometimes to a fault. The words washed over me, failing to adhere in my brain. I got lost in the past tense. It was impossible that he could be talking about my dad. Our dad. He wasn't—any longer. He was . . . not anymore.

I wore a black rayon dress, or maybe calling it a jumper is more accurate. It wasn't mine, but somehow it appeared that day as my only real option. It was shorter than would normally be appropriate for a funeral and had an unusual fabric belt that attached around my waist with a button. It draped loosely over my frame, which was rapidly diminishing from lack of appetite and the 24/7 adrenaline surge. When I picture that day, I see myself as a much younger girl, fresh-faced and fragile, and not as the twenty-eight-year-old woman that I was. Something about my demeanor evoked a childlike innocence. Now lost.

Maybe a rabbi was there to offer a prayer and kaddish. I can't be sure. Maybe someone else spoke? Mom did. Yes, she definitely did. And then, with David by my side, I did, too.

Dear Daddy.
We love you beyond words
You are the sun and the moon
You are our life
We will never forget how much you loved us
Or how much of you is forever
Inside us
I vow
Under this most beautiful sky
That has impossibly stolen you from us
That never a moment will go by
That we will not try to see your smile
Hear your laugh

Read your thoughts and
Try to see that magical glimmer in your eyes
We pray you are somewhere safe
And that you don't feel this
Crushing pain
But in case you do—
Please know always
That you are our idol
Our inspiration
And that the depth and intensity of our love is
Simply
Infinite

Eventually, the pace of visitors slowed. The phone calls were few and far between. But the huge gaping hole in our lives remained. It took on a life of its own. Breathing in long, slow, rhythmic breaths. Pulsing. And throbbing. All day, every day.

At some point, it became clear that we all needed to move. Both mind and body. Some days we moved backward and some days forward, but we had to keep moving, somewhere, anywhere but where we were. This became essential.

With my mom's encouragement and her assurance that she could manage things on her own, I returned to New York City and went back to work at Savoy Pictures. Normal sleep was increasingly elusive. I started to go into the office earlier and earlier each morning as a way to center myself and summon the strength to will my job to matter again. And frankly, as a way to be home less often, since my divorce from Dan was winding down.

Somewhere in the dark and dragging months that followed, quite unexpectedly, I found my Howie. He was Savoy's CFO, the number three person at the company after my former professor, Victor Kaufman, who was CEO, and his longtime business partner, Lew Korman, who was COO. Howie and I worked side by side, wholly professionally, for almost two years with mutual respect and an easy rapport. One day Howie, my friend and close colleague, who was himself in the process of getting divorced, touched my hand while comforting me at an especially fragile moment, and everything changed.

While I wasn't looking for it and surely didn't see it coming, there it was. It's a love story for the ages, and one that I can confidently say, after twenty-eight years of marriage, truly saved me.

Howie and I married on a glorious Sunday afternoon in May 1997. Perhaps not surprisingly, in the very same spot where I learned the news of the accident and where we held the memorial for my dad. Howie's two children, my new "stepchildren," Ilysa and Benji, were the flower girl and ring bearer, respectively. "Lissy," as we called her, was then ten, and Benji was eight. Together, we set out to build a new family. A year and a half later in October 1998, our son Michael was born. Two years later, our daughter Emily arrived.

So much happened so quickly, and yet, I was certain this was exactly where I was supposed to be.

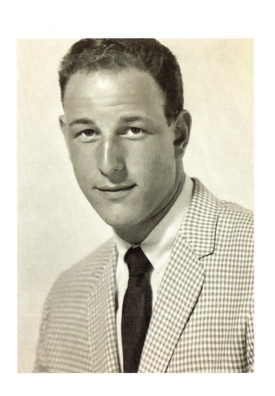

the space in between

This photo of my dad, taken on the occasion of my parents' engagement a little more than a year before I was born, so embodies his energy and charisma. It always makes me smile and cry at the same time. Even in this black-and-white photo, the dancing twinkle of his rich blue eyes comes through.

He taught me how to live and love fully—with purpose and passion and commitment. Thoughtfully. With intention. And doing exactly that has made every difference.

A more typical biography of my dad might begin: Michael Howard Waldman was born on May 22, 1943, to Leah and Enoch Waldman. He was raised, alongside his older sister Ann Sharon Waldman, later Ann Weiner, in a modest though comfortable middle-class home in the Bronx, New York, and later in Bayside, Queens. He went to Bayside High School and then to Queens College, where he graduated with a bachelor of science degree in 1964. He was married the following year to his college sweetheart, Jessica Friedman of Rego Park, New York, the daughter and only child of Ruth and Sydney Friedman. Michael and Jessica had two children, Stacy Pamela Waldman, born in 1966, and David Adam Waldman, born three years later in 1969. The family resided briefly in Babylon, New York, and then relocated to Westport, Connecticut.

Mr. Waldman worked in direct marketing and advertising for sixteen years. He started out at a direct marketing outfit called Hobi International, where he quickly became a vice president. He later formed Dione Lucas, a gourmet catalog and retail company in Manhattan. He then became president of Bevis Catalog Divisions, another direct marketing firm. In 1972, he left Bevis to form his own direct mail and advertising company, American Consumer Inc. Mr. Waldman sold American Consumer a year later to Film Corporation of America and stayed on as its president for another five years. In 1978, at age thirty-five, he retired. In the years that followed, until his tragic and untimely death at fifty-two, Mr. Waldman and his wife traveled extensively. He also

focused on his many interests and hobbies while concentrating his efforts on investing in and managing a growing personal real estate portfolio.

That's a solid biography. Other than his financial success at such a young age and his unusually early retirement, nothing much stands out as exceptional. Or out of the ordinary.

Oh, but he was both. And surely, it's the countless characteristics that exist in between those simple, two-dimensional sentences that truly make the man, that allow the depth and complexity of his life to jump off the page, full-blown and in living color.

Yes, he was a genius entrepreneur and mail order guru, pre-internet. His biggest successes included marketing the mood ring in the 1970s and the Dr. Atkins diet book, which was the first of its kind. But mostly, he sold American-themed products like a golden eagle belt buckle, coin-related collections, and the like. He retired very young but somehow never stopped working—his mind and appetite for knowledge were voracious.

He loved adventure and never shrunk from a challenge. He once had a pet monkey. He had a wicked sense of humor and an unforgettable, full-throttle laugh. His drink of choice was Tanqueray gin with lots of olives. He hated to wait in lines. He loved to windsurf (despite having little success) and fish for lobsters. He loved to be on or near the water, always. He liked to eat a whole pomegranate on his lap with a dish towel spread atop his belly. While a foodie of sorts, before that was a thing, he also happily devoured my mom's mush, which was literally a mash-up of ground hamburger meat, spaghetti, and yes, Heinz ketchup.

He never really liked any of my boyfriends (though he likely just hated the idea of them), but I'm nevertheless certain Howie would be the exception. He was playful. And sometimes very silly. And he had a hard time remembering names.

He was generous and loved giving (and getting!) gifts—though more than once, he got Mom some questionable pieces of jewelry that left us wondering. He once (in)famously smuggled a heart-shaped charm made of coral around his penis as he made his way through customs coming back into the US from an adventure abroad.

He loved music and exposing himself to new and interesting things. At some point, I discovered that Darcy made him mixtapes of some of her favorite songs. While I thought it was lovely that they had that kind of relationship, I confess it also made me a little jealous, too.

He had famously illegible handwriting and knew next to nothing about team sports. Before it was considered unsafe, but even after, he relished baking in the sun with Hawaiian Tropic #2 oil slathered all over his body. The coconut-soaked, sunshiny smell is hard to forget.

He was a tough businessman. He had the brightest mind but wasn't the best speller. He was an incredibly loyal friend, brother, uncle, and son. He was a passionate person, very focused, and always fun. He had a magnetic, electric energy and was fiercely devoted to his family. And . . . he loved celebrating birthdays.

I miss all these things. And literally everything else. Every minute of every day. I wish you could have known him, too.

coming home

Sometimes it's a certain scent or taste that takes you back to a precise moment. Sometimes a texture, pattern, or fabric will do the same. Long before I had an interest in photography or in photographing interiors and design, I was very connected to the colors, textures, and patterns that adorned my childhood homes. I am amazed at how easily I can mentally re-create spaces that I have no pictures of or how an image of one element of a room can instantly call forth the rest of the room into its prior three-dimensional life.

I have no recollection of the apartment in Forest Hills where we lived when I was born, before we moved to Babylon on Long Island. The house at 7 Star Court was on a cul-de-sac, but I can't remember anything about it, though I have a faint sense of the stairwell being positioned in the front hall. Any other memories from that time are surely born from photographs, like this one taken on the front steps on the day I was gifted my first bicycle, a green Schwinn with the requisite training wheels and a thumb-activated bell.

When I was four, my parents made the decision to move to Westport, Connecticut. They looked at various towns along the Connecticut coast before an acquaintance introduced them to Westport. They immediately liked what they saw there. Our first house at 53 North Sylvan Road could be described as a charming, antique home. It was near the road but had a lovely private back property and several small outbuildings.

According to family folklore, my parents were excited to share this fabulous potential home and invited my grandparents to see it. My grandfather was distraught that my parents were about to buy a house without the then-modern amenities of baseboard heating and the like. The exposed iron radiators were considered a failure in his mind, while my parents saw it as an endearing detail. Papa was so afraid that they were being taken for a ride that he implored my aunt and uncle to drive up from New Jersey to talk them out of it. Of course, Ann and Sid easily saw the appeal of the house and reassured my papa that it was, in fact, a beautiful home, and even a great deal at that.

I can't remember anything at all about the main floor of the house, and there are no known photographs to jog my memory. While there are also no photos of the second floor, I have a very clear picture in my head of its precise layout. At the top of the stairs on the left was my bedroom, a small and narrow rectangular room. I can recall, clear as day, how I had to be rescued by my dad when some stray bats from the attic made their way into my room. He assured me that all would be OK and to cover my head so they didn't fly into my hair.

David's room was just to the right at the top of the stairs, and my parents' room was a bit farther down the same short hall. I have a vivid memory of a large mirror sitting on the floor adjacent to their dresser. I sometimes stared into it to see if my face would in fact get stuck, as my mom warned, in whatever offensive expression I made. An oversized, plastic water jug sat on the dresser, slowly collecting pennies and other coins from my dad's pockets at the end of each day.

There are several existing pictures of the time our family spent there, including events like Halloween and birthday parties, riding ponies in our small corral, and me playing with sparklers on the back patio and wearing seersucker bloomers to cover my underwear. Or sitting with my rather fat, orange Tabby cat, Fluffernutter Peanut Butter Sandwich Cookie (a.k.a. Fluffy), on the bluestone front steps. But truly, those are the only images I can access. Perhaps I was too young, but the images don't conjure any emotion within me or even provide a broader context outside the fraying frame. Despite my Psych 101 professor's insistence to the contrary, I think I recall wearing pink snow boots, a fuzzy white hat with a large pom-pom, and a big parka while running through the backyard to see if the nearby pond was frozen through and could be played or skated upon. In this little moving memory, I was cold but excited. However, I'm not 100 percent sure that it wasn't all just a dream.

After spending one year as a kindergartner at King's Highway Elementary, which was only a mile or less from our house, we moved across town to 193 North Avenue. This place would one day become a magnificent home, but at the time it was a private, bucolic six-acre property with a pool, a tennis court, and a lot of work to be done. Somewhere along the way in its history,

one of the owners named the house Wisteria Court. A bronze plaque with a nice patina was engraved with the moniker and installed on one of the stone pillars marking the driveway entrance.

My five-year-old self was completely oblivious to the move and surely not consulted on it, but off we went. Changing schools at that tender age would have been daunting if not for the most incredible coincidence: My best friend Susan and her family, our neighbors from Sylvan Road, also happened to be moving to North Avenue. Right next door! As long as my best friend was right through the yard and reaching her didn't require any help or transportation, things were good. That's all I cared about. Nothing else about the move mattered.

When we first moved in, my bedroom in the North Avenue house was green and white and had clover-themed wallpaper. Any design details about the rest of the house, however, have long ago faded from my mind. But once the house was renovated several months later (or maybe it was years?), I find I have very robust memories of almost every room in the house. Sure, some of those memories build on pictures I've seen, but many more are so fleshed out that I feel certain I could sketch a furniture plan or even pull fabrics and samples to re-create every couch, chair, carpet, and wall covering. I have such a vigorous and confident awareness of the home's color, pattern, texture, tone: the plush, thick feel of the burnt orange rug under my feet in the living room; the exact spot where the wooden lazy Susan on the kitchen table had lost its sealant and was showing signs of wear; the spongy suede texture of the deep yellow wallpaper in my parents' loft bedroom. When meshed together, these little details are the very definition of *home*.

David's room and my own shared a wall. We were at the end of the hall atop the back stairway near the formal living room. The stairway was somewhat narrow and had a slight bend to it. A tall, blue-and-white chinoiserie-style ginger jar sat in a recessed alcove near the bottom stair. The carpet that ran down the stairs and hallway was a medium blue with little flecks of color.

Every school day morning, I stood in front of my bathroom mirror, struggling—always—to make my short hair do something different and more appealing than what it wanted to do on its own. I was not naturally gifted

in this area, but I eventually discovered that wearing one of my ski hats and placing it just so could help stabilize the wings of my bangs so that I could go off to middle school with at least a passable amount of self-esteem intact.

And then, like clockwork, my mom would come to the bottom of the stairs and yell up to David as if on cue: "David . . . what do you want for breakfast?"

He would always answer, "French toast."

"How many pieces?"

"Three!"

His enthusiastic response would fly down the hall, bouncing off the walls until it reached her and set her mission in motion. I sometimes mouthed the whole conversation to myself just to highlight the ridiculousness of this daily inquiry. I always wondered why Mom insisted on asking the same question each and every day if the answer was always identical. Maybe this was my way of acknowledging my disappointment that her question—her invitation—was always for David, never for me. I'd just have some Lucky Charms and be on my way.

Then one day, Mom explained this routine. One morning she had gone ahead and made French toast for David without asking. When he bounded into the kitchen and surveyed the situation, he blithely announced that he just wanted some cereal.

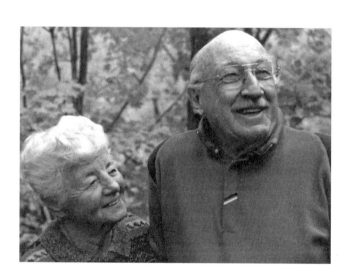

raisins (in the sun)

My father's parents, Leah and Eddie, known to me always as Granny and Papa, retired to Palm Beach when they were about sixty-two years old. Their apartment building, dubbed The Barclay at 3546 South Ocean Boulevard, was one of countless indistinguishable high-rises on the main north-to-south coastal route A1A. The building sat across from the Atlantic Ocean. Their apartment was on the ninth floor, the highest floor in the building, so the elevator button read "PH." My papa loved to make the (bad) joke that the letters stood for "Poor House," not "Penthouse." The ninth floor had as many apartments as all the floors below it, but their apartment was a lovely corner perch overlooking the ocean. It was easy to see how proud my papa was of their new place and how happy he was to welcome us all there whenever we could visit.

Their place embodied the stability, warmth, and constancy of my grandparents' exceptionally loving marriage. It always felt like a safe haven. The memories I associate with apartment 901 can be replayed as little video mementos in my mind:

Granny, all four foot ten of her, standing in front of the sink in a floor-length, floral-patterned house dress for what seemed like hours, cutting grapefruit and orange segments with her miraculous serrated paring knife to fill a huge jar of cut-up fruit. This was a staple of their diet. The jar was always depleted at breakneck speed when we came to visit. I can still hear the last squeeze of juice when she used to crush the remaining fruit carcasses in her hands so as not to miss a drop.

Granny, sitting at her dressing table in her black-and-white toile-papered master bath in front of a 50x magnifying mirror, examining her visage and holding a tweezer to pluck away any stray or offending hair, especially on her chin.

Papa coming home from an afternoon on the golf course, where he was only an average golfer, and reclining in the study on his plush leather Barca-Lounger, recounting the highlights of his round to us. He had the most

distinctive vocal tone and laugh. I so loved how he said the number three as if it had two very distinct syllables: "tha-reee."

In that same room, where I slept on a pull-out sofa bed, was a burlwood wall unit with gray glass that filled the entire wall and housed the television. Just to the right was a shelf with a drop-down front, behind which Granny and Papa kept goodies that they served to their friends when they played bridge or pinochle. I always loved how Papa said *pinochle*, emphasizing every syllable. There were usually a variety of nuts and maybe some plain M&M's stashed there, but there were always chocolate-covered raisins—an off-brand version—in a heavy crystal bowl. To me, they were irresistible.

With no effort, I can recall the exact smell, texture, and taste of those chocolate-covered raisins—sweet and moist, just a touch melty, maybe from being confined to the card cabinet, and just a little bit warm on the tongue. I spent the next twenty to thirty years of my life secretly trying to re-create that exact, perfect taste. I have yet to encounter a Raisinet or any other specialty milk-chocolate-and-raisin confection that even comes close to that precise combination of sugary deliciousness from Granny and Papa's cabinet. And I'm certain I never will.

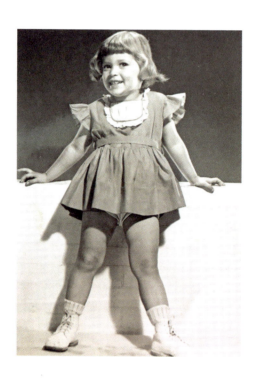

daddy's girl

My mom grew up in Rego Park and Forest Hills in Queens, New York, an only child in a relatively well-adjusted yet modest, happy home. Her father—in whose honor I was given the name Stacy, forever sharing a sweeping and elegant capital "S"—Sydney Friedman, was a bookkeeper. Her mother, Ruth, who I called Nanny, was an opera singer by passion—her stage name was "Ruth Gilbert"—but she worked in an office to help pay the bills. Ruth was older than most of my mom's friends' mothers. I wish I could recall if that was due to a later-than-typical marriage for that era, difficulty conceiving, or something else.

My mom adored her father, and it was thanks to him that she became a real baseball fan. She attended games and religiously followed the Dodgers when they were still in Brooklyn and then eventually the Yankees. My interest and love of baseball as a young girl and tomboy surely followed from that lineage. He also taught her how to do the *New York Times* crossword, a skill and obsession that she nourished and excelled at for the rest of her life.

When she was only eleven, her father died suddenly of a heart attack, and their little family of three—that used to get away from life in the city for a simple yet idyllic summer in the Catskills at a place called Shapanack—morphed into the far more fragile duo of Jessica and Ruth.

After that, my mom slept on what was essentially a cot in the kitchenette of their small apartment. Life wasn't easy. But that's about all she ever shared about that challenging time in her life. She never complained. Not about how exasperating and exacting her mother could be, and not about how this cataclysmic shift in her life impacted her daily life, her friendships, and her psyche. Nor did she grieve, at least not openly, the loss of her dad. Upon reflection, I feel terrible that I didn't ask more or try to understand how she was able to handle such a monumental loss at such a tender age. Especially knowing as I did that Nanny had a difficult personality. It was likely that young Jessica had to be both a daughter and a caretaker.

From that loss emerged a young woman with an outsized and startling strength and composure, one who was able to absorb and accept the path that life presented to her, no matter the pain. Years later, when faced with the sudden loss of my own father, she never attempted to equate the two events—which would have been a natural comparison. She never offered, "I know exactly what this is like, and here's what I suggest." She allowed—almost encouraged—me to face my loss in my own way, without judgment and with a deep and abiding compassion. Such a generous and loving gesture.

Though her generally sunny disposition camouflaged it, Mom was also a complex, multifaceted woman who carried a heavy emotional load. The shocking and instantaneous loss of her father, and then later the loss of her husband, took a toll on her in myriad ways. Yet she managed to compartmentalize those emotions and keep them tightly tethered. She found a way to get up every morning and to soldier on. She continued to pursue her passions and hope for a companion to share her days with. She never for even an instant put herself before her kids. And later, she took great interest and delight in forging relationships with her grandchildren.

The fact that her father died in the way that he did was always a part of the narrative of her life. But oddly, it was a simple sentence with little color or nuance. While it wasn't really my role as her daughter to try to further analyze the weight of that loss, from where I sit today, I feel that not doing so was a huge failing on my part—a missed opportunity to know her more deeply and to connect with her in the truest way possible.

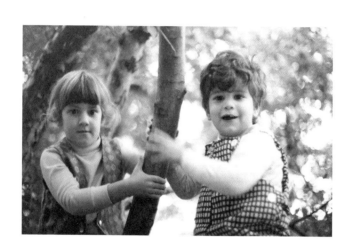

all is forgiven

I first wrote this in my journal when I was twenty-one and traveling solo in New Zealand in February 1987. Though I was exploring on the other side of the world, my heart and mind often drifted back to home . . .

My relationship with my brother was predictable and constant. Predictably loud and constantly at odds. Laborious, nerve-racking, hyper, then calm. A war of dominions. We created and exaggerated our individual personas and wrapped them securely in the envelopes of our bedrooms. For it was our rooms that so blatantly annunciated our differences.

The busy, green clover wallpaper infected the walls of my room like an incurable disease. I regarded the lime-green shag carpet and faux antique yellow, green, and orange furniture with equal contempt. The decor was too girly, antithetical to my decidedly tomboyish image. David's room was quieter in design; subtly masculine, it evoked calm. But as a preteenage girl, I focused instead on the scale, the power of space. Bigger is naturally better . . .

Perhaps if I had let my chestnut brown hair grow beyond the sacred threshold of my ears and adorned my still-shapeless body in more feminine attire, I might have felt attractive. Instead, I insisted that my coarse hair grow no more than two inches beneath my chin. I wore plaid Levi's shirts and unfashionably colored corduroys (light blue!). I contented myself with my rather shabby imitation of a twelve-year-old boy. But David . . .

His eyes were large, shapely, obvious, always signaling a certain sweetness inside. Their deep mahogany color—which blended effortlessly with his pupils—invited one to explore their mystery. His eyes were more intense and far less revealing than my equally large eyes, the color of which was still uncertain. His nose was small, freckled, unobtrusive. (Why is it that I used to think that people are born with their noses full size? Wishful thinking?) His lips were pinker, fuller, more defined. His smile was straight. His mouth imitated that perfect leaf we were commanded to sketch in art class. His face was alive, his expression pensive and curious. He was beautiful. And completely unaware

of his gifts. The blossoms of mature vanity were still tucked away—festering and fermenting toward the peak of ripeness at around age seventeen, when they would burst forward abruptly, arrogantly, often sarcastically, and proclaim, "Look how gorgeous I am!"

Fortunately, we didn't compete in looks. Neither of us cared. Of course, should it have occurred to me, I would have proudly deflected and announced "age before beauty" and emerged victorious. Instead, my agile mind sought to vie for power more deftly. My games, manipulations, tricks, ploys, and tales were met with screams, cries, and sometimes punches. I tolerated the volume of his rebuke and kicked back; twelve-year-old legs are stronger than nine-year-old legs, male or female. Right?

Does every older sibling take pleasure in taunting their younger sibling? Does every younger sibling fight back? Of course, he could have walked away, ignored me, refused to enter my kingdom of dominance, and gone off to read or play. Would I have continued to provoke him? Instead, he screamed louder, kicked harder, and tried to manipulate back. Perseverance. But to no avail.

And then . . .

Reconciliation. Everything felt different at night. Floorboards creaked and vibrated from imaginary footsteps. Windows cracked and splintered with frost as the winter cold chilled their panes. The silhouettes of tree branches outside my window swayed and rustled, forming an unmistakable human figure. The flames of the furnace two floors below collided, gurgled, and rearranged, sending clicks and clacks of sporadic noise through the aged house. To my tween brain, these suspicious sounds were surely the tell of an intruder. Each noise evoked a new fear, a new reckoning, a new attempt (from scratch each time) to assess the impending doom, to identify the interloper. Each murmur jolted me from my bed, causing me to sit up straight with back erect, eyes searching wide while cowering inside. The seemingly invincible mask of strength and control that defined me by day was willingly (not even reluctantly?) set aside in favor of comfort. The same mind that maneuvered with precision while the sun was still shining fell prisoner to an equally talented and agile imagination at night.

Unaware of all this mostly imagined drama, David was falling asleep just next door.

all is forgiven

I tiptoed through the halls, ready to recoil from whatever creature was lurking in the darkness. My brother's room was black. But the darkness was oddly welcoming. In it lay an unsuspecting, fearless nine-year-old boy.

I swallowed and, in an apologetic tone, called his name. He was momentarily startled but quickly calmed down. I humbly asked my question, which by now, he already knew.

"David, can I please sleep in your room tonight?"

His assent was inaudible but clear. We worked together to pull the extra trundle bed out from beneath his own. He didn't question my motives nor any reason for my brief but scary journey. The night tempered his rebelliousness. He welcomed me into his room with a half-asleep smile that was fully aware and seemed to say, "Goodnight, Stacy. You are safe here."

He lapsed back into slumber and, shortly after, fell fast asleep. The sheets were cold. The mattress was softer than mine. The noise from the radiators subsided. The tree branches outside the window seemed to stop dancing. The creaks from the house were understood and then ignored.

My little brother was asleep beside me. He seemed to have forgiven all.

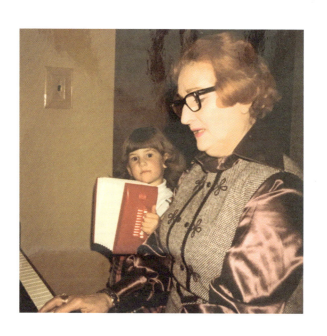

the minnybus

It's not fair or even kind to say that David and I had a favorite grandmother, but in truth, we did. Granny was a grandmother out of central casting. She was tiny at four foot ten, incredibly warm, the very best cook and home-maker, and despite her diminutive frame, she had an outsized place in all our lives and in our decision-making. She was a compass who unabashedly declared true north. She was adored, revered, and maybe even feared just a little, in that everyone only wanted to do right by her.

In contrast, my maternal grandmother, Ruth, whom we called Nanny, was, well, different. She was eccentric, outspoken, fiercely independent, and notably critical of my father. It was no secret that she wasn't a fan of my dad. Knowing that influenced how connected I felt to her. Nonetheless, I was interested in knowing her and all that made her different.

As a young girl, I loved her. She was a former opera singer and, by the time I knew her, was substantially older than Granny. Her hair color shifted quite a bit over the years but can perhaps best be described as a faded, amber-tinged pink. She regularly wore an armful of stacked plastic bangles, typically in a mid-century modern color palette. Her apartment had the unfamiliar scent of an artistic life lived mostly on her own. There was a piano. Lots of art and memorabilia. Busy floral wallpaper. Stacks of books. Miscellaneous tchotchkes. Nostalgia.

She liked her soup very hot, which I know from more than one embar-rassing exchange with a waiter at a restaurant. Her lipstick typically migrated outside the line of her thin lips. On more than one occasion, she had quite snobby reactions to my choosing baseball over ballet or plaid over pink. It was hard for her to hide her disappointment that her only granddaughter didn't share much of her taste or interests, at least not yet.

Because Grandpa Sydney died long before I was born, not only did I never know him, but I also never knew Nanny as part of a couple. Her singleness distinguished her, too. There was always something mysterious about her. To

be honest, I regret that I wasn't mature enough to really get to know her before she passed away. I asked her lots of questions over the years, but none of them were the right ones.

I can't think about Nanny without also replaying an incident that happened when I was in middle school. She had moved from her studio apartment in New York City to a small cottage on Long Lots Lane in Westport, not far from where we lived on North Avenue. My dad had generously purchased the house for her so that she could be near my mom.

One summer day, I was on my way home on a Minnybus, one of the local Westport buses that provided transportation along many routes throughout town in the 1970s. I was by myself, which was somewhat unusual, when Nanny boarded the same bus. She sat in the first row, and as far as I could tell, she didn't see me seated alone toward the back.

Just as I was about to walk to the front to surprise her and say hello, a group of obnoxious older boys started to heckle her—making fun of her hair or her clothes or her age. She never reacted or got upset. I'm not totally sure she heard them or recognized that their rambunctious comments were being slung at her. It's more than possible she was oblivious to the whole thing. But I knew. I heard. And I saw. And I did nothing. I was scared. I was afraid that if I intervened, the boys might turn their unwanted attention on me, or maybe worse, they would know that this crazy, pink-haired old lady was my grandmother. I was frozen. Quietly mortified and deeply embarrassed.

I sat in silence for what seemed like forever, though it was probably only a few minutes until she got up and got off the bus, a few steps from her street. As the bus continued on its way, I watched her slowly make her way down the road toward her cottage. I felt sick to my stomach, nauseated by my bad behavior. A few stops later—but far short of my original destination—I, too, got off the bus and set my sights on Nanny's house. I decided I would drop by and say I was in the neighborhood and wanted to say hi; I would say a friend lived nearby—what a coincidence? I didn't know how I would explain my unlikely appearance at her front door, but I knew I had to go anyway.

It was a beautiful, warm summer day. The sky was clear and the birds were chirping. Westport was shining bright, as it always does that time of year.

the minnybus

There were manicured lawns and lush gardens in every direction, the unforgettable and soothing scent of cut grass circulating above. There was a subtle breeze that day, the kind that made me take an especially long, deep inhale. Her cottage looked charming and idyllic, shaded by some fragrant trees in full bloom along the front walk. I knocked on the door and shyly called out her name so as not to startle her.

"Nanny, hi! It's me, Stacy!"

She greeted me at the door, as if my stopping by was a regular thing, and welcomed me inside with a warm hug. And that was it. She never said a word about the bus. And I didn't either. But I know she knew. And in knowing that, I knew she forgave me. All these years later, I still remember this episode as a low point. As someone who has few regrets, I am still so disappointed in my behavior on that day. I could and would do better.

in the fast lane

It wasn't a secret that Dad liked vehicles of all kinds. Boats and more boats. Cars, cars, and more cars. He liked to have lots of them. Motorcycles, too. Big ones and little ones. He was happy on all of them, just the same.

The previous photo, which also happens to sit on my desk, was taken at our Sylvan Road house. I love that my smile hints at the delight I felt being on that bike—any bike—with my dad. I was a touch too young—just four years old—to remember anything outside of the frame of this image. I can't even be sure that Mom allowed Dad to take us out on the motorcycle. More than likely, we just got to sit there with Granny supervising for a few moments in the fraction of a second it took to take this photograph.

Later at North Avenue, when Dad upgraded to a larger, cruising bike—a Honda GL1000 motorcycle—we were allowed to ride with him. The motorcycle was a rusty red color and had large black suitcases flanking the seat on either side. The bike's retractable handles were just the right length for passengers to hold on to.

Dad liked to take the Honda out on weekends, mostly Sundays, and he did so pretty much exclusively on exquisitely beautiful days. I don't know if he and Mom made a pact that he would only ride in good weather so as to dramatically reduce any chance of an accident from slippery or unsafe conditions. But that would make sense.

Sometimes, when David was still little enough to ride in front in between Dad's arms, the three of us would go out for a short spin together. Thirty to forty minutes tops, but typically less. More often, David and I would take turns going for a ride. There was almost nothing I liked to do more than ride on the back of that motorcycle, just me and my dad. I liked the rumbling vibration of the engine, how the helmet padding smooshed my cheeks and even made it a little hard to talk, how the cool breeze felt against my skin, how the sunlight danced through the canopies of trees, and how lit up and beautiful life was out on those lovely, winding Connecticut roads.

My still gangly, twiggy arms would wrap tightly around Dad's torso, which was typically clad in an old, incredibly soft T-shirt or one of his many striped polo shirts. I wasn't ever scared, but I sometimes held on like I was. It was a hug that lasted much longer than most hugs do. It felt like it might never end.

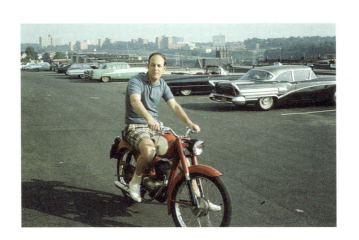

poison ivy

Growing up, it was well known that Dad was allergic to poison ivy. And oak. And sumac. I inherited that allergy from him and always had to be careful and vigilant while playing or walking in the woods—at home, at camp, everywhere.

I didn't really understand what it meant to be allergic. The only context I had was a story that Granny once shared—a story so terrifying that it made me do everything to avoid a similar fate. As Granny told it, when Dad was a boy, perhaps eight or nine, he somehow touched poison ivy, and the rash spread like wildfire all over his body. It was in every orifice, on every surface. In his nose and even on his penis. Across his back and all over his hands and feet. You get the picture.

His entire body was covered and crawling with a red, hot, bumpy, and inflamed rash that just wouldn't quit. It was so upsetting for my grandparents to look at, they feared my dad would never recover from the image of seeing himself in that condition. So they did what any caring and thoughtful (Jewish!) parents would do: They covered every reflective surface in the house—mirrors, windows, and appliances—to protect him from catching a glimpse of his reflection. Until it subsided. Which, of course, it eventually did.

men at work

When my dad was growing up, there were *lots* of interesting and acceptable professional pursuits, but the only ones that were ever in the running in his family were being a lawyer, a doctor, a dentist, or a businessman. I think they were mostly ranked in that order. While he was exceptionally smart, he was also one of those students who never really applied himself. School wasn't something he cared much about. So the prospect of additional schooling at a law or medical school wasn't especially appealing. My grandparents had hoped he might become a doctor, but his grades were not impressive. Thus, his prospects weren't great.

Oddly, in a family where business was what everyone did, he was encouraged instead to try for dental school. The story goes that Granny got Dad a carving kit that was intended to prepare students for the dental entrance exam. Apparently, he actually practiced. But on the day of the exam, when he was asked to make some adjustments to this plaster model of teeth, he used too much force—the opposite of a deft touch—and the whole thing crumbled in his hands. He left the test feeling a combination of embarrassment, dejection, and likely also relief. He arrived home and announced, "I guess I'm going into business!"

My dad had lots of offices over the years. One was very spacious and executive-like—not quite Gordon Gekko's Wall Street office, but still . . . impressive. Most of these spaces were far quirkier, more living room than boardroom. He joyfully commuted to one of his offices—located on the banks of Five Mile River in Rowayton, Connecticut—by boat! In every office, no matter the location or the broader decor, every wall was what we now commonly refer to as a gallery wall—a collage of framed pieces that are sometimes connected thematically or aesthetically.

Dad's gallery walls, to my mind, were more like a rambling path through his life. They included images of my mom and David and me, of course, but also of his friends and colleagues. These were interspersed with photographs of places he'd been or loved, taken by him or others. Pieces of art—sketches,

watercolors, paintings. Lots of boats. Cars, too. Waterscapes. Mementos of some of the accomplishments in his professional life: first dollars from various ventures, old stationery/letterhead or business cards, ads from an especially successful product launch. Each piece was typically framed with a colorful mat, never a gallery white. The color either pulled from or at least complemented the content it framed.

The small visual moments that he'd put together in this unique puzzle endlessly fascinated me. The chance to sit and stare and absorb every detail was my secret motivation for visiting him at the office. I was always looking to know more, to understand the unique and marvelous details that made him who he was. I believed some of that could be gleaned from those walls. It was a treasure map in plain sight.

Other than a one-time business partner and one of his secretaries, I can't picture any of the other people who were employed at his offices over the years. But I'll never forget how special it felt to be the boss's daughter. There was a presumption that if my dad was so brilliant and creative and accomplished, then maybe, just maybe, I could and would be, too.

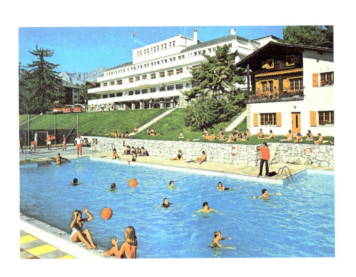

la moubra

I still can't completely understand what would have made me decide, at fourteen years old, to forgo my seventh and final summer as a camper at Pierce Camp Birchmont. Life there for me was pretty blissful. Instead, I opted to travel across the world to the International Summer Camp La Moubra in Crans-Montana, Switzerland. Perhaps I was looking for a change, an adventure, a challenge? But none of that really prepared me for what it would be like there. Many years later, I came across this letter from my dad, which makes sense to me in so many ways. It's consistent with what I believed his worldview was and reveals his perspective of me and how capable he believed me to be. The letter is confidence-infusing. Calming. *Full* of love.

June 29, 1981

Dear Stacy,

All your life, remember one thing. You always have a safe haven with Mom and Dad. We will never turn you away—our home is OUR home—Mom's, David's, Dad's, and yours. This is true because we love you, and you have lived your life to deserve the love we give. What comes next is some feelings, thoughts, and opinions—they're mine and you don't have to agree with them. All you have to do is believe that I believe them to be true and that the advice is for your good.

Yes, I would be disappointed if you did not give the camp—the experiences— 100%. You give everything else 100%, and once you get over the disorientation, the newness, the culture shock—you'll begin to see beyond your initial frustrations and discomforts with the new and perhaps strange people.

Life is so much more than you have experienced in the world, the safe world, that we have provided you. I felt that you were ready—are ready—to reach out and touch, get hurt, be rejected, be loved, smell strong new odors, learn strange and beautiful new languages, live with people who come from new cultures—new to you anyway—start to understand, to learn, to look at the world, with all its

problems, all its ups and downs, straight in the face and eat it up. Eat life up, digest it, and let the world become a part of you.

Growth comes from experience! Pleasant and not pleasant, we learn more from rejection and problems than from easy times and protected lives. Stacy, my love, my pride, my child, my young lady, my laughter, my happiness—sit back and think. Sit back and review what's happened and what's happening. Reach out. Fight to make the summer a rich, rewarding growth experience— to meet and try to understand more about our planet and its different people. Stacy, my love, you have the ability, the power, the mind, to make it work. Try to look forward, not away from the frustrations. Try to learn and absorb what's out there. One day, you'll be a lawyer and will have to protect and defend. First, you must understand and know.

Think of this camp not as a playground but as a class in life, an opportunity to experience a rare look, at such a young age, of what's out there. A very strong part of me says stick it out—but it has to be on your own terms, so you're comfortable.

Remember the beginning of the letter. You can always come home. You have earned that right because of how you live your life and our pride and love. But also remember that life, real life, is not always easy, yet we live it to the best of our ability. We can't always just go home and make bad times disappear. We can make them better by confronting them.

Love you. Respect you and trust you—

Dad

My memories of that camp are so intertwined with the photographs I saved that it's hard to discern the real memories from constructed ones. But certain things do come back to me more three-dimensionally than others. I remember some friends: my bestie Lauren with whom I was traveling and am still very close to, and also others like Nevil and Joy, Kent and Andy, and maybe someone named Peter, too.

I felt overwhelmed sharing a room with a complete stranger and her pungent body odor. I felt insecure about my fluency in French, the language in which I was expected to converse. I traded in a place I knew better than almost any other for this wholly foreign one—in a different country, no less—where

I had no seniority and no real identity, either. I was so far out of my comfort zone, it was hard to balance.

That's not to say this place wasn't extraordinary. As a planned excursion, our camp took a small plane and landed on a glacier alongside the Matterhorn. We skied down from that rarefied place at the top of the world on the somewhat slushy summer snow. Photos illustrate how truly beautiful a day it was. And outside the frame of those images, I know I felt beyond fortunate to have this experience.

One day on a hiking excursion, I twisted my ankle. Two of the other campers, one of whom happened to be the crown prince of some lesser-known Middle Eastern country, carried me down to the base of the trail. I was unable to participate in the rest of the field trip. Instead, a counselor named Thomas with a curly shock of blond hair was assigned to hang with me for the rest of the day. I have no idea how we were transported, but we ended up in a small café and had a lovely Swiss meal. Thomas taught me my first Italian: "Io amo les fragoles," or "I like strawberries." And I really did.

I recently discovered the journal that I kept during that time in Switzerland. In fact, many of the memories I just described track with what I had written. Interestingly, at the end of each day's entry, I noted how I was feeling in red pen. "Strange, tired" at the end of day one evolved into "uncomfortable" and then "awful, homesick" at the end of day six. My mood that day may be what prompted Dad's letter.

In short order, the notations morphed into "relaxed, free, satisfied," "great, confident," and even "superb." In between, I found a few negative comments: "frustrated" or "in pain" when I'd sprained my ankle, "impatient," and even "pressured." All told, a blind reading of the journal depicted what I would now consider the normal ups and downs of a fourteen-year-old girl's experience living in a new country, away from her family for the first time. No doubt my dad's letter—while there is no mention of it in the journal—weighed on me as heavily as he intended it to. I was able to rise above my fears and discomfort to make the experience a mostly positive one that set the stage for a lifetime of exploration in foreign lands.

the big w

Growing up, we saw the Weiners so frequently, I really thought of Auntie Ann and Uncle Sid as second parents and Darcy and Glenn, my two first cousins, as sister and brother. It feels as if we saw them every other week, but more than likely, it was once every four or five weeks. Our families took turns hosting at our place in Westport or at theirs in Saddle River, New Jersey, which was about an hour and a quarter drive away.

My memory of our time in Saddle River comes in spurts—discrete but powerful glimpses of experiences there: a certain smell, taste, or feeling. The Weiners' house was magical to me. It was set back from the road by a rambling field of wildflowers and had a gray-weathered split-rail fence out front. Turning left up the driveway at mailbox 104 always made me feel happy and excited about the day ahead.

My aunt's aura was impossible to miss. It was a mixture of warmth and whimsy, kindness and joy. While it's probably not accurate, I feel like she always had a project for us to work on. Sometimes it was elaborate, sometimes not, but it was sure to be creative and engaging. Although she was working as a clothing designer at the time, at her core, she was and would forever be an artist—a painter, a sculptor, and a photographer. Auntie Ann never left anything to chance, nor did she expect us four kids to just hang out. While we inevitably came up with games for ourselves to play or a mission to undertake, a fort to build or an obstacle course to construct, the tone she set underpinned the time we spent together. She always made me feel special.

I confess that as the oldest of the cousins, I was naturally the one in charge, but I didn't always use my power for good. To this day, I regret that I didn't always treat David like one of the gang. Sometimes I made him work harder than my cousins ever had to, to be in our self-anointed cool kids club. Once when our families went together to the Mohonk Mountain House for a weekend hiking getaway in upstate New York, I was especially unkind to David. I made sure he couldn't get the same "club" sweatshirt from the gift shop

that the three of us all had or the correct stuffed animal that I had deemed "required" for admission.

Thinking back, I really can't explain why I acted that way. Sure, David was sometimes difficult at that age, not unlike many little brothers. But he surely didn't do anything specific to deserve that treatment. Now that I'm a parent, thinking about that behavior makes me so uncomfortable and sad. It makes me wonder what was missing from my life at that time that I needed to wield my power over the group at his expense. As angry as he got, he always managed to forgive me, even if he didn't forget. I am grateful that he let me off the hook for my mistakes when he didn't have to. That forbearance gave me the space to figure out on my own how I wanted to conduct myself in the world. As a sister, a friend, and eventually a citizen.

Other memories of Saddle River run the gamut from winning The Big W, the annual family tennis tournament, and riding ponies in the back corral to the smell of the kitchen—Ann's noodle and rice dishes spring to mind—and the shape and feel of the mustard-colored leather dining chairs that had horse heads carved into each corner.

I often hung out in Darcy's room, where we talked about boys and clothes and camp. I sometimes envied the fact that Uncle Sid woke his kids up each morning with an unsolicited shoulder rub or that my aunt welcomed the day with her singsong refrain, "Good morning, sunshine." The air was always full of love and light. I treasured being there.

Our visits to Saddle River typically took place on Sundays. Dad especially loved driving his forest-green (later dubbed "Waldman Green") '77 Rolls Royce on Sundays, when traffic was light and time was less pressing. The scent of the leather seats was so distinct. The matching green carpet underfoot in the back seat was so plush and comfy, David and I even took turns curled up on the floor. Yes, the floor. Surprisingly, we could each tuck into that space comfortably. There was an 8-track tape player built into the burlwood dash, and we would listen to all of Dad's favorites: John Denver, Cat Stevens, Joni Mitchell. That music and those songs instantly conjure up our many rides along the Palisades, where our life and luck were so very big and round, bursting with promise and joy, quietly invincible.

Not only did we routinely see the Weiners on weekends throughout the year, but we also vacationed together. We used to travel to Sugarbush in Warren, Vermont, on winter weekends to ski. It was more than a five-hour drive there and back each weekend. That is, until my parents decided to buy a place in Windham, New York, where Ann, Sid, and the kids already had a home. Our families were so close, it never occurred to me that it was unusual to spend so much time together. I didn't question or fully appreciate how welcoming they were to us. Windham became an incredibly important place for us as a family. This wider social circle for the adults and the kids quickly surpassed whatever was going on at home in Westport. While I am sure there were a few weekends I missed because of an event back home, I had no hesitation or fear of missing out. Windham became a home away from home.

My parents were solid skiers. They learned to ski as adults, so perhaps they would never be as natural as us kids grew to be, but they enjoyed it nevertheless, and the time spent on the slopes with us and with new friends they made. Our house was slopeside and had a somewhat unexpected decor. A spiral staircase went up through the center of the house, and it had an open floor plan that featured my parents' collection of unusual antiques. The dining table could seat fourteen easily and was often the scene of our family Thanksgiving celebrations. The main living space included an oversized stone fireplace and was flanked by two contemporary beige leather couches. Dad and I could routinely be found napping there, in perfect parallel, most weekend afternoons.

We still own this house today. It has gone through several renovations that have eliminated any noticeable resemblance to the original house, but for me, the place overflows with memories of my childhood there: chasing Dad around the main floor trying to put ice cubes down his hooded sweatshirt and laughing, being awakened by him at 7:30 a.m. so as not to miss the best snow of the day, roasting marshmallows and chestnuts by the fire with friends. Dad especially loved chestnuts. There was so much laughter. I can still hear it gleefully reverberating in my mind, even today.

The Windham house has become a place of solace for our kids in much the same way it was for me growing up (though minus the built-in social circle of

friends' kids). Though I have happy memories of being there as a kid, spending time there now has its challenges, too. The house and furnishings have morphed it into a completely new structure, but there is still something in the atmosphere—at that exact latitude and longitude—that sometimes makes it harder for me to breathe. It's as if the lingering particles of words spoken, breaths taken, meals enjoyed are still suspended and hovering there, creating a gentle fog of sadness that envelops me each and every time. I am working hard to overcome that sensation and to allow my time there to flourish and bloom in its new incarnation and this new phase of life. Some days I feel the fog dissipating, allowing new memories to be made and take hold.

Lately, each of our four kids has taken to using the Windham house with their own friends and families, extending the legacy of the place even more significantly. That gives us great joy. Wonderfully, our four grandchildren—Avery, Jackson, Evyn, and Brooks—are the newest generation to look forward to weekends there. They started to tear up the slopes as early as age three. They've inherited some of the magic on that mountain, and with it, an ever-enduring connection to the great-grandparents they never got a chance to know.

⌜the graduate⌟

January 24, 1989

Dear Stacy,

Today is one more step in a life experience full of adventure—hopes, accomplishments, and learning—and yes, also full of problems and some tears. I hope you tackle the adventure with the same thirst for knowledge and achievement as you have college. I really think life is a game—the winners have equipped themselves with a desire to win and the knowledge and work ethic that allows them to achieve success—and yes, luck!

Stacy, I hope luck falls your way, but I know you have the mind and talent to enjoy the best that life has. You continue to make me proud and happy at the way you are growing. I love you very much and look forward to sharing life with you to the fullest.

Dad

boys to men

Though he never came out and said it, getting my dad's blessing for the boys, and eventually men, I became enamored with was not something that came easily. Or maybe ever. That's not to say that he didn't encourage me to pursue relationships, just that he wasn't going to be jumping up and down with excitement over them. His tone was more cautious and reserved. He was perfectly OK with me making, or maybe wanted me to make, my own mistakes. He was much more interested in helping me put the pieces back together post-breakup than he ever seemed to be in engaging with whoever I was currently in love with.

He thought nothing at all of childhood boyfriends beyond a casual "He's cute." No matter how much I might swoon or fixate on specific guys, he quietly and unceremoniously let them come and go with the ebb and flow. Then he sympathized an appropriate amount with whatever heartbreak I might experience along the way.

Dad found other ways of showing me how high his standards were. Like the time he repeatedly called my entirely lovely, handsome, and smart date for the ninth grade Holly Ball formal dance, Greg Prybylski, by the wrong name. Over and over, he referred to him as "Ed Pryzbisky," followed by a devilish giggle. I think it became somewhat of a sport for him.

Not much changed with Rob, my first serious boyfriend when I was a senior in high school, nor with Tim, my first college boyfriend, either. Dad must have intended for his general indifference to signal to me that, despite the intensity of my young love and each of their merits as a person and a boyfriend, he wasn't too impressed by either of them. And that this mere fact alone would eventually facilitate the undoing of it all. Though that was a bit arrogant of him, he wasn't wrong. Each of those relationships was formative and wonderfully all-consuming, but they naturally ended in due course.

When I announced that I was planning to move to Illinois with Tim the summer after freshman year, Dad was absolutely against it. Tim was from Evanston and had a house-painting business with his brothers there. He was a second-semester senior when I started as a freshman, and so, in many ways,

he was already an adult. That made him an older man and put him in a different league—physically, emotionally, and let's face it, sexually—than the high school boys I'd been hanging around with.

As was often the case, I was able to convince my dad that I was mature enough to handle this experience; that he shouldn't worry it was too serious, too soon; and that I would show him how responsible I could be. I offered a loosely drawn plan (which, honestly, I never really executed) whereby I'd get a part-time job and take some art or maybe dance classes to make it a productive summer.

It was obvious that Dad didn't love the idea of me ending up with Tim, despite his many positive attributes. Tim's father, Tom, was the Episcopal bishop of northern Michigan. While he was truly one of the kindest people I'd ever known, his occupation—an esteemed leader in a Christian church—was hard to swallow. Dad couldn't quite imagine Tim being a match for his Jewish daughter (albeit a Reform Jew), but once again, he never forced the issue. He never told me I couldn't or shouldn't. He let me explore new people and places. He wanted me to.

Tim and I eventually parted ways. More boyfriends followed. Then a fiancé who ultimately became an ex-fiancé. And then my first husband. In every iteration of my love life, Dad was steadfast in his support for me while also insisting on sharing his honest assessment of my chosen partner. It was extremely stressful whenever Dad expressed his concerns about whoever I was dating. It became harder and harder for me to move forward with a relationship he hadn't endorsed. Especially when he pointed out a shortcoming or red flag or character trait he felt might not serve me or the relationship well.

Although I was really in love with Dan, or surely believed that I was, it was clear that my dad wasn't convinced. On some level, getting engaged and intending to go through with marriage was my way of drawing a line in the sand. I had to stand my ground and show Dad that I didn't need his approval; that I was a strong, smart, and independent woman; and that I could, would, and *should* make big life decisions without his input and even disregard his advice.

Despite my best intentions to separate from him in this way, I admit that it didn't really work. Dad's voice in my head was often so pronounced, it easily drowned out anything else that I might be thinking, especially when it was contrary to what he thought.

My wedding with Dan is a complete blur. There are morsels of memories there, but they are so faint as to be indiscernible. Even at the wedding, which was marvelously lovely by all accounts, it was easy to see that Dad was checked out. The father-of-the-bride toast was so flat and bland and completely devoid of positivity or any emotion. Was there a band? Did we dance a lot? Was there a father-daughter dance? I've completely wiped away any memories of what transpired.

After the reception, my parents drove me and Dan to our hotel, fifteen or so minutes away. No town car. No limousine. No romantic send-off or departure. My parents drove us. In their car. To this day, I remember getting out of that car and quietly panicking that I'd made a huge mistake.

Dan and I flew to Switzerland and honeymooned in Zermatt. I'm not sure how we'd decided on that destination, nor do I remember much about the trip there. But I'm pretty confident there was a train involved. When we reached the hotel, the very first thing I did was ask the hotel operator to connect an international call to the US to speak to my parents. I was more than mildly aware that this was not the best of signs. Instead of deliriously falling into bed with my brand-new husband after a long trip, my mind was elsewhere, back home with my family of origin. Nevertheless, I was determined to give our marriage a shot.

One night for dinner, I wore a pair of pink silk Nicole Miller boxer shorts adorned with images of matchboxes from NYC hot spots. Because it was winter, I wore black opaque tights under them and a black blazer. What can I say? Borderline inappropriate. But back then, it felt flirty and fun. The sights and sounds of the village near the hotel are largely absent. I have no memory of any skiing. Of the weather? Of any romance? It's all completely gone. Evaporated into the ether or unceremoniously locked away in some compartmentalized vessel in my brain.

I've always thought it ironic, or perhaps just symbolic, that when I finally found the perfect partner—my Howie, my *beshert*, my without-a-doubt-meant-to-be love of my life—that my dad wasn't here. He had no chance to weigh in. No judgment. No approval. More profoundly, perhaps they couldn't both be in my life at the same time. My dad's absence made space for Howie's presence and for the real, mature, and quite extraordinary connection and relationship that followed.

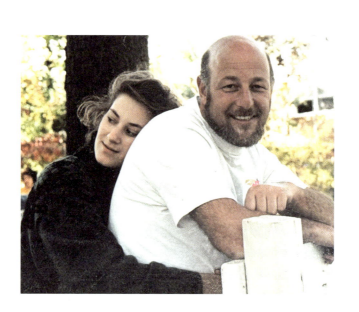

my forever valentine

February 14, 1989

Dear Stacy,

You've been my special valentine for 22 years—there is no way you're going to have a Valentine's Day without a valentine. Stacy, you've earned by being who you are—a caring, concerned, and giving person—the love of so many people. That special man, that special job, that special family and life will all happen. Give it time and lots of effort, and I promise the highs will be exhilarating and make the lows seem less disastrous.

Happy every day.

Dad

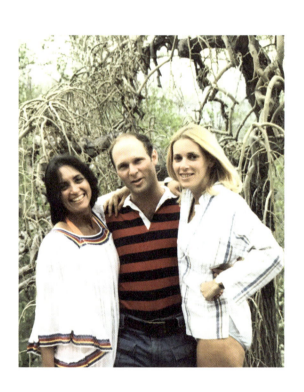

sex education

My parents were not what you would call hippies—not in the least. Yet they were fairly progressive and not at all uptight. It was not unusual for them to walk around their bedroom suite naked or to be naked in front of us—I promise it wasn't creepy. They were just unapologetically unselfconscious and comfortable in their own skin, which is a trait I wish I'd inherited more of.

One of their closest friends, the ever kind and exuberant Bob Selverstone, was a sex educator and therapist. Though it's unclear how much of Bobby's facility with that topic influenced how sex was discussed in our house, there is no doubt his expertise normalized it. I never really had "the talk" with my mom. I learned what I needed to by osmosis, but I do remember this: My senior year in high school, Rob and I had been dating for a while, and our mutual infatuation was more than evident. It was serious enough that my mom assumed that sex wasn't out of the realm of possibility in some form or another.

One day, she offered quite nonchalantly, "If you need to talk or need any help getting some birth control, just let me know." Despite the openness in our household, I was both a little embarrassed and sort of amazed that my mom was so cool about it. I wasn't going to have to sneak around, as many teenagers did, desperate to keep what was happening a secret. It was a moment that opened my eyes to—even if only a bit—the myriad layers underneath her mom-ness. While this fact was never really top of mind, it allowed me to see my mother *also* as the young—and no doubt sexually active—woman that she was. For a brief moment, we had similar concerns as women, not just as mother and daughter. While that felt a bit alien to me, I also really liked it. It instantly made me feel more mature than I really was.

A month or so later, things had progressed with Rob. One random day while driving somewhere with my mom (perhaps the orthodontist?) along Easton Road, I got up the nerve to take her up on her offer.

"Um, Mom . . . remember when you offered to help me with some birth control? I think now would be a good time," I said, believing that a lack of

eye contact with her while she was driving would make the topic a bit easier to broach.

She audibly gasped. Flushed. Flummoxed. And then kind of spewed out a series of words that made little sense. I laughed, then reminded her of how chill she had been about it just a few weeks before, but it was of no use. As much as she wanted to be that cool mom, it just wasn't completely comfortable for her. So much for that, I mused.

I got the birth control on my own.

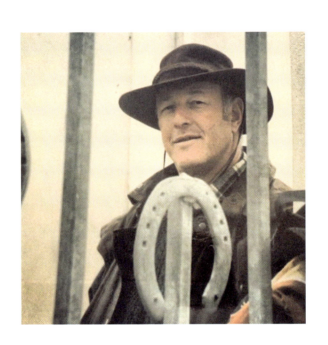

luck of the irish

In September 1994, after long and careful research and planning, Dad and I decided to tackle a ten-day horseback riding expedition along the Irish coastline, beginning in Sligo. It promised to be beautiful, rugged, and lush. We dismissed the guided trips we saw advertised in all sorts of exotic and majestic places that prided themselves on offering adventure sprinkled with luxury. Or maybe it was the other way around? While that type of trip appeals to me more now, Dad and my twenty-seven-year-old self thought ourselves more capable of a true adventure. So we opted for an advanced ride with no guide. Just me, Dad, and a map. Surely, we were better and brighter than the rest and could manage to find our way. Surely others, who were less capable, intuitive, and calm than us, had survived. We could, too. Or so we reasoned.

Dad and I were already strong recreational riders. We were both comfortable on horseback, though not exactly well trained. We knew enough to handle a trail ride or a gallop on the beach. But because this trip would be a much more involved undertaking and we wouldn't have the benefit of an instructor nearby for the first time, we decided to really prepare and train for it.

I'm not quite sure what prompted the idea that we should travel somewhere together at all. I was newly married to Dan, and yet, I hardly remember discussing it with him. Traveling with my dad seemed perfectly natural in the lexicon of my life and our family. But no doubt, comments from friends and colleagues suggested that it was a bit unusual, especially given my recent marriage. People were amazed that I preferred to travel with my dad over my husband. By this time, I had already started working at Savoy Pictures, and my coworkers were surprised that I would spend precious vacation days in that way . . . and that my husband seemed to support that choice.

Perhaps that should have been a sign. My dad had made it very clear that he didn't think Dan was the right guy for me. Though he would never have gone so far as to forbid the marriage, he wasn't shy about sharing his concerns and misgivings. Perhaps I thought the chance to be alone with my dad for this extended period of time would give me the chance to win him over to the idea

of this new marriage, to show him that I was still the same daughter that he so adored, and to make him realize that Dan had attributes he was choosing to ignore—he was a smart, charming, and loving person worthy of a chance to prove himself, at the very least.

While we were still in Connecticut, we arranged for jumping lessons at a stable in Wilton. For several Saturdays, we tried to get as expert as we could on an English saddle. My years of riding at Camp Birchmont came back to me, and we both progressed rapidly. The practice sessions were also a wonderful opportunity to be together, working toward a common goal. I looked forward to the sessions with giddy anticipation.

Then finally, it was time to depart. The cab ride to the airport sticks in my mind more vividly than it should. I was alone and traveling from the city. Dad was coming from Connecticut, and we had planned to meet at the airport. The traffic that afternoon was especially heavy. Though we'd both left with plenty of time, I felt anxious as the cab inched forward on the pothole-cratered Grand Central Parkway, fearful I would miss the flight. I was excited for our adventure and for the time together, but I admittedly felt a bit off about leaving my life in NYC, even for a couple of weeks. I arrived just in time to enact my own running-through-the-airport parody. Thankfully, I made the flight, but with hardly a moment to spare. Seeing Dad at the gate calmed my nerves immediately—"You're safe. You're home." I happily settled into the adventure.

After a long flight to Dublin and a train ride, we finally arrived at Horse Holiday Farm to select our horses and prepare for the ride, which was set to begin the next morning. Having settled on the horses—Dad's was Maeve, and mine was Lasor—we set out on a short ride with a guide to be sure that we were happy with the horses and comfortable in the saddles. A German woman named Andrea who had been working on the farm for a few months invited us to follow along—and so we did, galloping along the beach, over dunes, and through preternaturally green fields. The scenery was spectacular, and the horses were calm and confident, making us believe the adventure ahead would be more than manageable.

The next morning, around 11:00 a.m., we packed up our gear, saddled up, and were on our way. Only minutes into our ride—truly not even five—with the stables still in sight, we came to a fork in the road. Our first test. We

luck of the irish

consulted the map, looked at one another quizzically, and decided that we must be at the first green ragged line on the map, the one requiring us to turn right. So we turned right. The horses failed to indicate our mistake and willingly followed the reins. Moments later, we found ourselves staring at a wire fence that forbade further passage. We laughed hysterically (and somewhat nervously) at the ridiculousness of our novice error and wondered how we would actually be able to find our way with only this poorly rendered, unscaled map as a guide. Then, as if on cue, it started to pour.

Somehow, this was funny and not frightening. Within minutes, we were soaking wet. But I was with my dad. And so, all was right in the world.

In the days that followed, we mostly found our way—either because the map surprised us with helpful milestones or random markings on trees and stones fortuitously indicated which direction to follow. Once in a while, we made a wrong turn without realizing it, and then an hour later, we miraculously reconnected with the right path, highlighting our error. Along the way, we stopped at tiny pubs in tiny towns, fortifying ourselves with food and the occasional pints of Guinness. (Dad, not me—I hate the taste of beer.) We walked the horses side by side down rural wooded lanes and meandering forest paths, talking about life and just enjoying being together. Each evening, after four to eight hours on horseback—and some divine intervention—we would arrive at the designated farmhouse for a home-cooked meal and a warm, though not always so comfortable, place to sleep. Remember, this was decades before Airbnb.

The exact details of that trip have largely faded. I've only faint sensations of the scenery and the people we shared meals with and those who opened up their homes to us with warmth. All these years later, it takes only an instant to recall how it all felt: the brisk breeze against my face as I rode along the beach; sand flying up behind Lasor's hind legs as he crisscrossed the deserted shoreline; the quiet, contemplative time away from my everyday world and the white noise of my New York City life; feeling disconnected from so much of the world and yet very connected and stabilized by the empowering strength of my dad by my side.

That experience was so grounding and truly centering. It was a guidepost in my life, then and always. I was aware even then how fortunate I was to have this exact man as my father. How his limitless adoration lifted me up, each and every day, and shaped the way I saw the world.

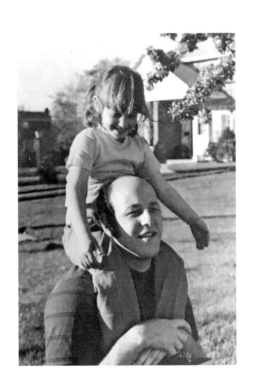

ashes to ashes

At low tide, the water that flows in and out along the marshes outside of Mom and Dad's house empties to almost nothing, revealing a muddy bottom with thin, meandering rivulets that look like a child's scribblings on a wet, sandy beach. But at high tide, the water rises so high it covers much of the marshland, as well as many of the little inlets that jut in and out from the shore. It's remarkable to witness the transformation that happens every day—twice a day, in fact—and how dramatically the secret workings of the tides and the weather can impact the topography.

It's unsafe and surely unwise to take a boat in this marshy area without knowing exactly where you are in the tide cycle or how much water your boat draws—or requires—to remain afloat. After the memorial, I can be certain we waited until just the right tide to venture out to the spot we'd decided was best to spread Dad's ashes.

We all knew that he wanted to be cremated and that his will and other documents had directed this. Of course, no one could have anticipated that the circumstances surrounding his death would almost necessitate it. The horrifying reality was that the fiery explosion from the crash incinerated his body, rendering it practically unrecognizable without dental records. His ashes were delivered to us in a simple black cardboard box, wrapped first in a heavyweight plastic bag tied with the same twist tie you'd use for a loaf of bread. Can you imagine the mental gymnastics required to really absorb that all that remained of our robust-bodied, blue-eyed, six foot two, long-legged, sun-kissed, baldheaded, hairy-backed and -chested, strong, and handsome father was a block of soft, compacted ashes barely eight inches wide?

I still can't process it.

When I think back to that day, I have to correct myself when I imagine the scene. In my mind's eye, I see everyone who is dear to me. But Howie wouldn't have been there; we weren't together then. So maybe that means Dan was there instead? Mom hadn't yet met Carl at the bereavement group, which

would start a few months later. David and Yvette were already a couple, so I imagine Yvette must have been there. But I don't remember. Not David, not Mom. Although, of course, I know we were together. In fact, in my memory, I am so deep in a cold and dark tunnel of misery that the seemingly endless sunshine barely cracks through. The warmth of the early September day can't permeate the seal that I've secured around myself. I am moving through time and space with a noticeable delay, still unsure whether the ground beneath me will hold, unsure whether I may just keep falling.

At some point, it's decided that we should begin to spread the ashes and let the breeze carry them for a short ride before laying them gently on the water's surface, where they will rest for a bit and then, slowly, sink to some spot underwater where they will reside. For a bit. Until another boat, or a bikini-clad teenage girl on a paddleboard, or a young family with their happy laughter and in matching yellow kayaks comes by. And then the water will churn and the ashes will swirl, swept up in the motion of the water only to be redeposited again a few feet or maybe several yards away. Until the next time.

I dig my hand into the bag and grab a handful of the soft and chalky substance, suspending my extended arm over the starboard side of the boat. I can hear the faint sound of my heartbeat pulsing deep in my ears as if I, too, am underwater. The urgency and finality of this moment is making its way into my tunnel. In the instant before I open my fingers to let his ashes fall, I am overcome with emotion, perhaps some kind of wild desperation. Before I can recognize what I'm doing—or even stop myself—my hand involuntarily goes instead to my open mouth. The tears streaming down my face mix with the ashes into a smoky paste that tastes like the end of the world.

I somehow gag, gulp, and swallow.

by the sea

After the accident, though I returned to my life in New York City, I was still trying to figure out which parts of my life "before the accident" I should and would continue with going forward. I felt a near-constant pull to be back in Connecticut. I wanted to be closer to Mom and to David.

In fact, I could see that David could use some help and support managing the family real estate business. While he had excellent natural instincts and a solid interest and work ethic, David was fresh out of college. He was bright and raring to go but also inexperienced. He suddenly found himself in charge of a complicated business venture. We were lucky enough to be able to bring on Lance Sauerteig, a brilliant and überexperienced adviser and consigliere, to help navigate the business through those early days. I decided I should go back to Connecticut to work with David for the time being and offer my own limited skills to help keep the ship afloat.

Though we were not yet engaged, Howie and I started to look for a home outside of New York City, close enough to Westport to make my new role reasonable and viable. We didn't want to create an untenable commute to New City, New York, where Lissy and Benji lived with their mother. Both of us were determined to prioritize the kids and our new family. We spent several weekends looking in Greenwich, Stamford, and Westport. While visiting Mom on Surf Road one Sunday, she mentioned an open house she'd seen advertised. There was a newly built house just across the channel and easily visible from her home. We figured it was worth looking at, given the proximity to Mom's house, even though we never dreamed we could afford a place on the water, and certainly not at that juncture in our lives.

Howie and I went over to the open house. The developer, Jay, was standing in the kitchen talking to another couple who were older, perhaps empty nesters or retirees looking for a new home. The views out the back of the house were just stunning. We could see Mom's house, of course, but also an expansive swath of tidal marshes and gorgeous inlets punctuated by swans and

egrets. The scene was set to the soothing soundtrack of the tide flowing out. The serenity was overwhelming in all the best ways. This was a true retreat. We stood in the backyard, which was still only dirt with a new pool under construction and incomplete irrigation pipes popping up here and there. Holding hands, we looked out at the marshes just beyond the berm, where Dad's ashes were scattered. We barely had to utter a word between us; we both just knew. This was the place. Our place. It had to be.

Before we'd even looked through the entire house, we tried to ask Jay a few questions, but he was too distracted and suggested that we come back in thirty minutes. Naively, we acquiesced and went back to Mom's for a bit. When we returned, we found Jay in the kitchen, shaking hands with the empty nesters. They'd made a deal?

Before I knew what was happening, Howie asked to speak privately with Jay in another room. He shared a piece of our story and told him about the accident and my dad. He somehow conveyed how important it was for us to live there and that he would agree to whatever terms were necessary to make it so. Unexpectedly, wonderfully, Jay was swayed. He had heard news of the tragedy and somehow believed it was meant to be. The house was ours.

There are wonderful advantages to living in the town where you grew up. It's hard to replicate the kind of groundedness and belonging that comes with being "home"—not to mention the intrinsic confidence, familiarity, and sense that you naturally fit in. Though we very consciously chose to live here in Westport *and* in this exact place, to raise our own family here, there is also a constant longing in the air for me, which can be heavy and bittersweet. Countless memories are always swirling and circulating overhead.

I've always believed it fitting that we should live here—within eyeshot of the past and Dad's presence, the last place I saw him alive. Getting the house was a sign that he was watching, hopefully approvingly from above. Perhaps it was something he orchestrated from the heavens so that he could witness the unimaginably beautiful love that lives here and know that I was safe and fulfilled. So that he could be close to the grandchildren and now great-grandchildren he never got the chance to know in life.

I listened to a favorite podcast recently called *Kelly Corrigan Wonders*. In a

conversation about grief, the writer Anna Quindlen spoke about "the continual presence of an absence." That phrase captured the tone of what I carry with me. The loss of my father and my cousins hovers around me always, invisible to most. In many ways, being in the same place exacerbates and illuminates the missing.

In truth, I wouldn't want it any other way.

Most days, Howie and I take a morning walk in and around the neighborhood that typically lasts about an hour or an hour and a half and amounts to four to six miles. Before Howie retired, I walked on my own or with a friend. I'd often share a daily photograph on Instagram—of the sky or a cloudscape— that I'd taken along the way. No matter the exact route, the daily walk always includes a deliberate and reflective stop for several minutes at the entrance to what was my mom and dad's home.

This gives me a chance to talk to my parents, sometimes aloud, to tell them what is happening in our lives—both the joys and sorrows, accomplishments and disappointments. I tell them what I'm feeling anxious or troubled about and where I might need some help. I ask for guidance about very serious things and even, less frequently, about the more mundane and ridiculous, like wanting great weather for a graduation party. I talk to Darcy and Glenn, too—and try to tell them what we all do, each day, to remember and pay tribute to who they were in our lives. And then I resume my walk. It's a hard thing to do every day, but it's very meaningful. It's an expression of intentional connectedness for which I am forever grateful.

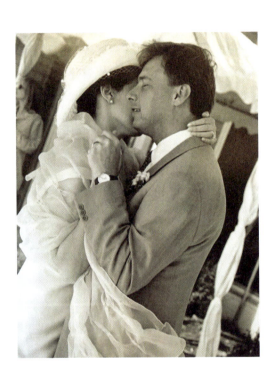

oh, deer

On May 18, 1997, Howie and I were married in my parents' backyard on the peninsula that forms the end of Surf Road in Westport. In many ways—actually, in every way—it was the perfect place to say our vows. Surrounded by the tidal waters that had long defined my family's home, we felt imbued with the spirit and energy of the joy that lived there and also, importantly, with the memories of all we had lost.

Since my dad was not there to walk me down the aisle and this was a second marriage for both Howie and me, we decided to walk down the aisle together, signifying the weight and strength of the decision we had made to spend our lives together. It was a small, tented afternoon wedding. Seventy-five guests, our dearest friends and family, attended the ceremony on a chilly but clear day. Despite the crushing losses felt by so many in attendance, the day was all about love.

During the ceremony, when our closest family members held the wedding chuppah made from Howie's grandfather's tallis over us, a lone deer appeared in the marshes across the channel. It was defiantly out of place, at risk to its own safety. The deer had made its way to the last seemingly stable piece of land above the water and paused, watching the ceremony quietly and attentively. It remained there, motionless, until the ceremony concluded and we triumphantly made our way back down the aisle as husband and wife. Then the deer disappeared.

Several of our guests, even the most skeptical among them, remarked that it was impossible not to feel that my dad had temporarily shapeshifted into that deer so that he could be there—where he would have and should have been—to bear witness and offer his approval and blessing.

Much later that night, we were settled into our hotel suite at National Hall, not three miles down the road in downtown Westport. We eventually fell asleep, exhausted and exhilarated from the festivities and the enormity of that day. Sometime around 4:00 a.m., my dad appeared in our room. I know

that sounds impossible. But he was there. Standing beside the bed—not translucent or ghostlike, not floating particles like a teleported apparition. Solid. Stable. Technicolor. *So* very real. I can no longer recall if we spoke. Nor what he was wearing, though one of his corduroy button-downs with the leather patches on the elbows feels right. In that moment, I heard what I needed to hear: "I am here. Always watching. And I love you."

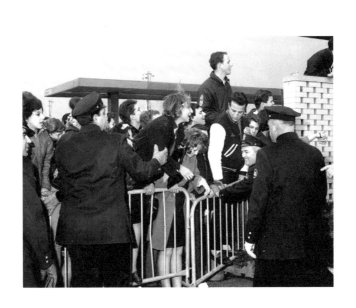

beatlemania

In November 2012, my mom mentioned in passing that my dad had been at what is now John F. Kennedy International Airport in New York City when the Beatles first came to America.

What? How was I only now learning about this? I was so stunned that this incredibly cool fact was shared as an afterthought. Then when Mom explained that there was actually a photo of him in the crowd that appeared in one of the New York City dailies the following day, I became instantly obsessed. I had to find that photograph.

My first call was to Dad's forever friend Steve Singer, a.k.a. Ringer, who, not surprisingly, was the real reason that Dad ended up at Idlewild Field to welcome the Beatles on February 7, 1964, along with a crowd of about four thousand others. Steve was always incredibly sweet to me. He and Dad were deeply bonded. He was also a *huge* music lover, and it was easy to understand why he wanted to be there for this historic moment. No doubt, my dad didn't know much about the Beatles, but he surely loved the idea of witnessing some kind of happening, and so, off they went. Steve wasn't sure which newspaper had carried the story and, oddly, hadn't saved a copy, but that didn't deter me from digging deeper. He confirmed that the photo existed, and I wouldn't stop until I found it.

After a few dead ends, I was encouraged to reach out via email to David Hinckley, a longtime writer for the *New York Daily News*, and I tried to describe the image I was looking for: a picture of a young man (my father) who had apparently shimmied up a light pole to get a better view of the arriving boy band.

Gratefully, Mr. Hinckley's kind reply led me to Angela Troisi, who handled the archives for the paper and was a known wizard at finding things. Simultaneously, I had the wonderful reference librarians in Westport and New York searching for available microfiche or microfilm. I spent several hours in a musty room at the New York Public Library's main building on Fifth Avenue

poring over badly scanned pages, checking every edition of every paper in the span of days surrounding the event. Then Angela and her team at the *New York Daily News* shared a link to an online database where I might be able to find the picture. After only a short time scanning the files, there it was!

Sitting at my computer, I screamed when the black-and-white image jumped off my screen. I cried. It was just the sweetest victory to have unearthed this artifact. That's my dad, perched on a stanchion to get a better look at the band, in a timeless and wonderful photograph by Phil Greitzer.

I was able to purchase a license of the image from Getty Images for $234.32. I made prints for me and my brother, and it remains tacked to the bulletin board in my workspace. It only took nine days from start to finish to accomplish this needle-in-a-haystack discovery—but I was relentless. Determined. Motivated by an ever-expanding need to re-see, re-view moments from his life, before mine even began. I wanted to know as much as I could about who he was as a man: where he went and what he saw, how he moved through the world. Each moment that I can access, like this one, fills the space between us and breathes life into the moments just outside the frame.

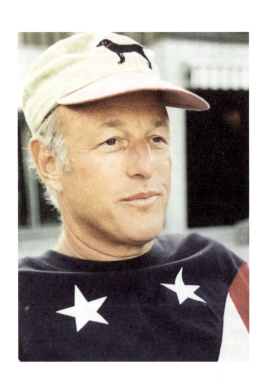

mr. newman

Growing up, Thanksgiving was always a highlight of the year. A time filled to overflowing with family and friends, a picture-perfect reminder of the unusual closeness of our extended family. While no one in our family was especially gifted in the kitchen, and I can't really recall *any* of the flavors of our annual turkey day meal, conjuring up the feeling of that day and the extended holiday weekend is simple. The boisterousness was like a balm, easily soothing whatever might be on our minds or the challenges of our everyday lives. Thanksgiving was always a welcome escape—a return to the womb, almost, where I would be enveloped by a warm, protective layer, safe from the rumbling world outside.

In stark contrast, Thanksgiving 1995 was traumatic. It stood out then as a harrowing symbol of what our family had been reduced to and illuminated the depth and power of the emotional riptide that formed in the wake of the accident. Sharing Thanksgiving with my aunt and uncle was impossible those three short months later. There must have been a conversation about whether we would forge ahead with the tradition of sharing the holiday together, but it was more than clear that the Weiners weren't even open to considering it. The ire was far too raw and the blame too intense to pretend things were otherwise. The concept of family as we had known it up until August 26, 1995, had been wholly rewritten, or at least indefinitely suspended. The sting of that reality made an already excruciating situation worse.

In the end, David, Mom, and I ended up at the Meeting Street Grill in Westport on Thanksgiving Day. Just the three of us, with a waiter, at a table, in a restaurant. It was deeply depressing. Impossible not to cry. I felt empty in a way I couldn't recognize, crippled by this hollowed-out version of one of our favorite days. I am not sure any of us tried to pretend it was OK, that this rendition of Thanksgiving could still be lovely and meaningful. None of us had the strength to try.

And then something unexpected happened. A little sprinkle of stardust fell

from out of the blue and buoyed our spirits, at least for a short while. A few tables over sat Paul Newman and Joanne Woodward. Yes, that Paul Newman and Joanne Woodward. At the restaurant. On Thanksgiving. Paul and Joanne, as locals tended to call them, lived nearby, so it wasn't totally random to see them. But given the occasion, and the weight of what we were processing, it felt like nothing short of movie magic—a sign from above that things could be OK, that maybe everything was not as dire as it seemed.

People had often remarked that my dad bore a resemblance to Paul, so that detail was not lost on me. Their presence brought some much-needed light to an otherwise very dark day. When we were ready to leave, and frankly relieved that the meal was concluded, there was a moment outside where we somehow connected with Paul and Joanne—a gracious word or two was exchanged, and then, through my tears, I shared the story of what had happened. Our family tragedy. Still so raw. And Paul Newman embraced me with a warm, fatherly hug that carried such understanding, love, and kindness. It lasted for longer than you might think. Lingering. Confident. Calming. And then it was over. For a few brief moments, I let myself breathe.

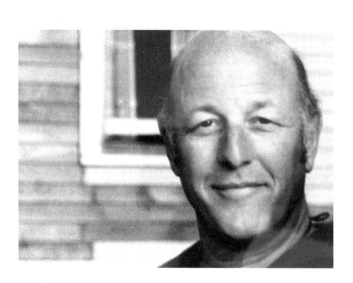

walking in memphis

November 5, 2004

Dear Mr. Cohn—or, perhaps I can call you Marc . . .

I have crafted this letter at least a hundred different ways—in my mind that is—and each time I have had the pleasure to see you perform live (many years ago at the Supper Club, this past summer in Ridgefield, and again last evening in Tarrytown), I feel compelled to write you. And then, I spend the next week talking myself out of it. I guess, not so this time.

Nine years ago, on a startlingly beautiful and unusually clear August day, I was sitting on a chaise overlooking the Long Island Sound, waiting for my father to come home and listening to your first album. Again. I had the CD playing so loud in my headphones that nothing else existed other than your music and that view. Sheer perfection. And then, ironically, on that fateful day, during the chorus of "Ghost Train," I was jarred back into the real world by the news that my father's seaplane, which he was captaining, had crashed on Block Island, killing my father, his passengers (including my two first cousins), and an older woman on the ground. He was my best friend, my biggest fan, and the center of my world. He was larger than life. He was 52.

In the days and weeks that followed, as I made my way very slowly through a new world that made little sense, your music, your voice, was my anchor. And in many ways, it is still a touchstone for me. Little things happened that made me believe I needed to reach out to you . . . your song would come on the radio at a telling moment; I wandered into Garry's frame shop (he had been a friend of my father's when I was young), and eerily, no one was inside . . . but in looking for Garry, I stumbled upon an autographed and framed album cover—Marc Cohn—again. Shortly after that, my mother changed physicians and mentioned his name in passing. Your brother.

I was heartbroken. Frightened. Angry. Lost and confused, I looked everywhere for a sign. Of something. Or a path to somewhere.

I am certain that I am not the first and surely not the last person to tell you how moved they have been by your work. But for me, it has been like

intravenous therapy—potent and direct and straight to my heart. The depth. Pain. Calm. Awe. Admiration. Longing. Loneliness. Fear. Love. Intimacy. All of it—somehow works for me as a catharsis—at once bringing me back to that horrendous moment nine years ago and then fast-forwarding through the highs and lows that have followed. I fell blissfully and permanently in love to the notes of "True Companion." We named our first boat (an inflatable raft, really) in honor of the hope and strength we found in your words. You have—yes, unwittingly and perhaps even unwillingly—been there with me all along. And though I am known to weep—often uncontrollably, as I did last night during "Healing Hands"—I come away from the music feeling more connected to what I have lost. And it keeps me ever wanting more.

I have yet to discover—admit?—my real motivation in needing to convey any of this to you. Perhaps it is as simple as my upbringing. When someone gives you a gift, you thank them. And I simply could not ignore the import and meaning of the gift your music has given me. For many years and for years to come.

With great admiration and appreciation, Stacy

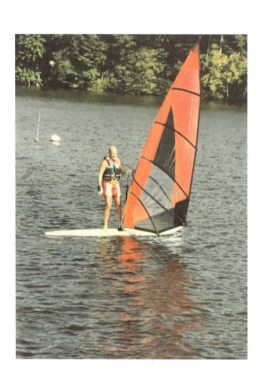

windsurfing

One day when our son Michael was about three years old, he was out playing in the front yard with his babysitter. When he came inside, he told a story that was hard to process. He shared that he had been talking to Grandpa Michael—as we had come to describe my dad with the kids—about windsurfing. *Windsurfing.*

As it happened, my dad was an avid but totally unaccomplished windsurfer. He loved the challenge of it and could often be seen out in the lagoon by his house trying and retrying. Falling and falling again. Once he famously made it from his dock on Bermuda Lagoon to the Peck's Ledge Lighthouse and back—not a small feat for anyone, but far more impressive given Dad's already well-known lack of finesse. It was obvious to me that he had set a goal and was determined to keep at it until, through pure will and a little good luck, he actually got there. But what made Michael's announcement so unusual—yes, other than the fact that he claimed to be having a conversation with a grandfather whom he never knew and who had died years before—was the idea of windsurfing.

At the time, windsurfing was no longer in fashion. It had mostly been replaced by other water sports of the day. Howie and I couldn't imagine a scenario where three-year-old Michael could have been exposed to or even learned that word. We were simultaneously dumbfounded and delighted. We took it as a sign that my dad was watching us, still connected to and conscious of our everyday lives, hovering invisibly overhead. Windsurfing became a symbol of that connection, and I held fast to it, ever wishful that Michael would have another chance encounter.

Each year on the anniversary of the accident—when the day can be practically counted on to have perfect weather as it had in 1995—we gather. It's always me and Howie. David and his wife, Yvette. Most often Mom joins us, too. And then, whichever of our collective kids is in town and available will

come along. We always gather at high tide so we can safely reach the place where we scattered his ashes by boat.

The memorial is brief but powerful. We say a prayer aloud. Howie presides over kaddish in Hebrew. And then, while we throw some just-picked flowers in the water, we each make our own quiet reflection. Sometimes someone may share a story. We honor and remember. As the current and breeze gently scatter and draw the flowers away, we remember and we cry. No matter how much time has passed, momentarily reliving that unimagined and unexpected day when life as we knew it became something else entirely carries with it an intensity that never seems to diminish.

On that day fifteen years later, while waiting for my brother to arrive for our annual memorial ritual, Michael, then about eighteen, was sitting in our family room typing on his laptop. He had been learning about screenwriting and, in that context, was creating a dialogue between himself and the grandfather for whom he was named. On paper, he imagined a conversation with my father that could only happen in his mind (and his heart). And then, something quite amazing happened.

On a windless day, Michael saw a bright neon sail coming down the channel. He yelled out that he could see someone windsurfing in the water just outside our house. Windsurfing? It wasn't even a thing anymore. Literally, no one does that. Incredulous, I jumped up to look, and sure enough, there it was. With its electric pink sail, it was impossible to miss and beckoning for attention. Even with no perceptible wind, the windsurfer sailed east toward the lagoon—the very lagoon where my dad used to practice—and then, just as quickly as it had appeared, it vanished.

Shortly afterward, the family all gathered on our boat and motored into the lagoon to see just where the windsurfer had gone. Knowing that there was no outlet, they should have been easy to find. We scoured every dock looking for the recently used sailboard and its captain, anxious for an easy explanation. We found nothing.

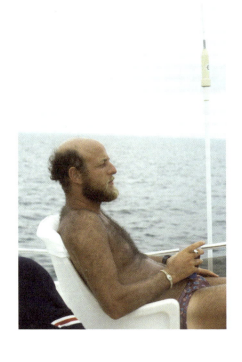

north avenue

My dad was a smoker, apparently. I've seen photographs of him with a cigarette in hand or one hanging from his mouth, like this one on his boat, but I don't remember him smoking at all. I don't remember recoiling from the smell, as I do reflexively now when passing a smoker standing outside a New York City office building, clearly jonesing for a much-needed drag. What I do remember are the boxes, or rather cartons, stacked up in his closet cabinet, lying in wait. The red and white graphic of the Marlboro logo is imprinted on my brain. Dad smoked two or even three packs a day at his peak. At some point, though, something prompted him to stop. It must have been something beyond the fact that it was incredibly unhealthy. Perhaps he was spurred on by incessant prodding from my mom, but whatever it was, once he decided to stop, he quit once and permanently. True to form—he was always determined and steadfast. He just stopped cold.

The cigarette cartons were just one of many curiosities housed in the master bath and closet suite in the house on North Avenue, where I lived from age five until I left for college. The bathroom was grand in scale, though not fancy. As you approached, directly ahead was a large, floral stained glass window with shades of blue, green, yellow, and white. My parents' shared closet was to the right and wasn't of any real interest to me. Mom's clothes hung floor to ceiling on one side, and Dad's, less packed and colorful, hung on the other. If, instead, you turned left at the window, you would come across a treasure trove of countless gray-ivory melamine drawers and cabinets to explore. Treasure hidden in plain sight.

The rest of the bathroom was primarily a bright royal blue and white, with earthy and roughly finished ceramic tiles and an occasional accent tile with a blue and yellow flower motif. There is a photo of me getting ready there for Halloween one year, when I donned a homemade robot costume and my serial number was SX-DC (a nod to R2-D2). I can't be entirely sure that I remember the tiles organically. The tub/shower combination was all blue tile with white grouting and was absolutely huge. It required stepping down two very deep, steep steps to reach its floor. This, I am sure, is a memory, as there are no

known pictures of that feature. Since it was a place my teenage self plotted to use whenever my parents were away, I am certain the memory stands.

Mom's cabinets and drawers were full of costume jewelry and columns of bulky, colorful sweaters, many of which she knit herself—on a streak that seemed to last for years. A grape-colored turtleneck with multicolored flecks that she wore frequently, and which set off her very blond locks beautifully, was a favorite. When she wore it, it always beckoned a cozy hug.

Dad's drawers and cabinets, though, were what really intrigued me. Aside from the cigarette cartons, which I largely tried to ignore—there was *so* much to see and wonder about. He kept money there—crisp hundred-dollar bills, coins, and foreign currency left over from his last trip abroad. He had several money clips that he used in lieu of a more typical wallet. But the real attraction of the cabinets was his ever-growing collection of camera equipment and the rows and rows of unused, mostly Kodak-branded film. Endless canisters housing coiled memories yet to be unfolded.

Whenever I could, I spent time taking out and examining the cameras and lenses, mostly without permission. I was always curious why he had so many and how they differed. I still count his ample-to-excessive photography stash as one of the main inspirations for my eventual profession. At the very least, it planted a seed that later bloomed fully. Truly, each time I make a picture, layered somewhere in that fraction of a second lies a connection to my father's largely unstated hobby. I believe it is a quiet and constant pull that always leaves me wanting more.

Then there was the smell. Dad occasionally wore Polo by Ralph Lauren and Aramis cologne—I know because I can picture the bottles—but the one scent that I associate with him, which can, in an instant, unleash an almost genie-like apparition of him, is Zizanie. I still have his bottle today, with its steely gray exterior and the little white plastic applicator that sits on top instead of a typical spray nozzle. I think that means it's more of an aftershave than cologne. Either way, the fragrance, first released in 1932, was described as woodsy and masculine, a rich blend of patchouli and sandalwood. For me, it's oddly intoxicating, incredibly soothing, and magically transporting. One whiff and I can pretend, for at least a fleeting instant, that he is right by my side.

The rest of the house holds so many memories for me. I dare say it's the

primary setting for countless dreams over the years, a kind of main character in the stories of my life. I could likely sketch out and re-create almost every corner of that rambling, antique home—from the country kitchen to the formal dining room, which was wallpapered in an elaborate pink pattern adorned with peacocks, I think. We used that room rarely, mostly for holiday dinners. It had a Dutch door that dated back to the original house as well as a buzzer on the floor intended for summoning staff that was no longer operational—also a relic from the original 1791 structure.

On the other side of the kitchen, there was a cozy den that featured an indoor terrarium of sorts. There was a raised level with lots of plants and a neon-green frog sculpture, which my brother and his friend Judd accidentally broke while playing ball inside. On the opposite side of that room, there was an antique hearth that was rarely, if ever, lit. We did, however, leave notes and cookies for Santa there for one or two years when we decided that being Jewish shouldn't preclude our participation in Christmas—a holiday we otherwise largely ignored as a family.

Continuing through the house, there was a large powder room around the next corner and access to a screened-in porch that had a selection of white wicker furniture with lovely floral cushions. My feet were always cold when I was out there, which makes me think the floor was some kind of cement or stone and not wood, but I'm not certain. Based largely on pictures, I know we used this porch for my brother's DIY projects. It was also where we held his at-home bar mitzvah. We congregated out there whenever company came over on the weekends, since it offered a lovely view of the grounds and easy access to the outdoors and a nearby hammock. It was a natural place to entertain.

The most majestic room in the house was the formal living room. It had high ceilings, several different seating areas, and a huge window seat at the far end; it was the perfect perch on which to gaze out at a field punctuated by lilac trees. I like to imagine that my parents enjoyed appetizers and cocktails with friends there before dinner; it just felt like a space that deserved that kind of use. Large but intimate, sophisticated and also impressive. No doubt they felt proud of how beautiful and inviting that space truly was.

Back on the other side of the house, near the extensive closet previously described, my parents had a newly constructed, two-story master suite. This

was an addition to the original house and had a much more 1970s vibe to it. Maybe even a little mid-century modern in tone.

The lower level had a small exercise room with some equipment, some of which Dad sold through mail order, including small chrome dumbbells, resistance bands, and a Suzanne Somers ThighMaster that Mom used on the regular. There was also a wooden roller thing that can best be described as a contraption you were supposed to sit on lightly so that the rotating sculpted slats would essentially massage away any excess fat on your backside and thighs. It definitely didn't work.

There was a ballet bar on the mirrored wall and a small sauna, which I used only a few times, but it was a frequent indulgence for my dad. The rest of that level included a sitting area with chairs, built-in bookcases around a TV, and a lovely wooden desk. Next to the desk was a beautiful painting, almost photorealistic, of a blond-haired woman resting her head on her arm on a desk. She resembled my mother in some ways—her hair texture and tone certainly conjured her look. Her physique could have been Mom's, but this woman always felt sad to me in a way that seemed other and foreign—and thus, very much not the way I saw my mom. Later research revealed it to be a work by the American realist painter Helen Bacon Hoffman. In all the moves and houses since North Avenue, that painting always came along. I still have it.

The sitting room was the scene of a mock trial that I initiated after I damaged the car pretty badly while pulling into the garage one day. I insisted on arguing my way out of punishment, or at least trying to. I sat along the bookcase bench, facing my parents as judge and jury, and made my case. The garages at North Avenue were up the driveway a bit from the main house, so it wasn't uncommon for Mom or Dad to pull up to the front walk and get out there so they could more easily bring in any packages.

For some reason, on this particular day—I was fifteen and hadn't yet gotten my driver's permit—Dad asked if I wanted to pull the car into the garage. Of course I did. I was excited and delighted at the prospect. Since I would be going less than fifty yards, it seemed more than manageable, and I didn't hesitate to accept. Perhaps I was overconfident—likely I was—but basically, truthfully, I just missed the mark. I misjudged the width of the garage and how close I was to one side and badly dented and scraped the length of both passenger-side doors.

In my panic (and embarrassment) at having failed at something seemingly foolproof, I made up an implausible story that there was a rock in the path of the tires and it unexpectedly shifted the car to the right. Of course, no one was hurt. And of course, it was accidental. And of course, no one was buying my ridiculous story. I was sent to my room and told that they would think about the appropriate punishment and how I might contribute to repairing the car.

At the time, I was taking a business law class at Staples High School, and my textbook was in my room. I decided to use this sequestered thinking time to write a brief supporting my cause that could potentially free me from the burden of responsibility for what I'd done. Admittedly, taking full responsibility for my actions was not the first thing I thought to do. I scoured the textbook for some legal doctrine to hang my hat on and eventually landed on something that I thought could work.

Business law is all about contracts. In order to have a binding contract, you must have an offer and an acceptance—which we clearly had here. But I quickly learned that certain types of contracts must be in writing to be binding (like real estate, etc.). In particular, an oral contract with a minor is not binding. "Stacy, will you please put the car in the garage?" Therefore, I wasn't legally bound by the consequences of my actions. Morally and ethically, this argument was a stretch. I can still picture my dad's reaction to my presentation and how proud and impressed he was that I was able to put that together so quickly.

Though I surely shouldn't have, I won the case. I made an earnest apology, and my punishment was waived by the court. Interestingly, the lesson I learned was not about how to avoid punishment or how not to take responsibility for something that was most certainly my fault. Instead, I felt rewarded for using my mind. For doing the research. For making the argument and for advocating for myself. These were all things my dad valued, and my parents' decision supported that lesson in an indelible way.

Returning to my parents' master suite, the upstairs was simply a bedroom and a bath. It hung loftlike over the lower level and, as a result, felt very spacious. Just past the bath was a sliding door that, somewhat unusually, connected their room to mine. It was the junction of the old part of the house and the new. The lock on the door was made of shiny brass and a bit finicky. I never

felt too confident that it was locked even if it appeared to be. This connecting door, at least to my mind, provided some additional comfort to me on many a night when I couldn't tune out the old house noises and had to ask my dad to please check the house for possible intruders.

I used to knock on the sliding door before entering and then sheepishly admit that I was scared and needed Dad to do the rounds to reassure me that no one uninvited had made their way inside. On at least one occasion that I can't completely obliterate from my mind, I walked in on my parents in the throes of lovemaking. Let's just say, no one was very happy about that. On one of these occasions, I believe I said something super compassionate and sophisticated like, "Oh, no . . . *gross!*" After that, I was much more careful about coming and going through that door.

I am routinely reminded of fragments of North Avenue: my dad walking down to the pool from his master suite completely naked, my brother hanging my stuffed Snoopy from a basement closet rafter with ketchup blood around its neck and chest, finding small bags of Dad's marijuana stash in a defunct file cabinet. However, it was the guesthouse, which we called "The Barn," that reverberates most clearly in my memory.

The Barn was an old carriage house from the original residence. Although it was still an outbuilding from the main house, it had been renovated so that it was comfortable and usable all year long. The focal point of the main space was a blue, oversized sectional that could easily seat fourteen or more people (or sleep eight or nine tweens). It was used on countless occasions for sleepover parties, make-out sessions, and more. It was there, at one of the first boy-girl parties of my friend group in fifth grade, that we played spin the bottle. And where I started a brief romance with a boy named Eric Brown when we ventured to share "seven minutes in heaven" in a cozy, hyperfragrant cedar storage closet.

The Barn had a small, city-style kitchenette that was used more for plating than cooking, but we surely reheated plenty of cans of Campbell's tomato rice and Kraft mac and cheese on the stovetop there. The countertops were black slate and quite rustic. There was a pass-through to a round dining table where we'd enjoy pizza and birthday cake and later sodas and eventually beer. There were two black leather Eames chairs flanking the billiard table

that sat in the middle of the great room and over which hung two colorful, Tiffany-style pendants—incredibly vibrant remnants of the space that I still (and forever shall) own.

Suspended from the ceiling nearby and reachable with your pool cue were wooden, abacus-like counting beads that we actually used to keep score. We used the billiard table *a lot*. For actual games and also as a surface for snacks and more when we hosted parties. There was no TV that I can recall. On the walls surrounding the sectional were built-in shelves and lots and lots of framed photos and memorabilia, which was a recurring theme in all Waldman spaces, largely dictated by my dad's interest in those things.

One oversized framed piece—for which I have looked many times over the years with some determination, hoping it was somehow saved—enshrined an invitation to a summer orgy party that my parents hosted one summer while David and I were at camp. The front of the beige invitation displayed a dark brown line drawing of a Rubenesque, naked female figure eating grapes. Guests were invited to The Barn to participate in a whole range of activities including X-rated tennis (to watch or play) and lots more. Skinny-dipping? Definitely. Partner-swapping? Quite possibly.

Also on display within the frame was a "best of" sampling of the RSVP cards with the most clever or funny replies highlighted. I can even picture the loopy handwriting on some of the reply cards. I promise you I took these at their word and completely believed that the party happened as described. I never considered that it might have been a tongue-in-cheek front for an otherwise tame, suburban soiree. I am still not sure which version is true. And it doesn't really matter.

All these details feel precious in a way they were never intended to be. They have taken on an outsized place in my mind as literal and symbolic vessels for what once was our exquisitely beautiful family and a life full to overflowing with promise, imbued with all the meaning that was made in those spaces and the indelible bonds that formed there. And blossomed. No matter who has lived there since and who may come to live there one day, the delicate and powerful fibers of my childhood and the spirits of my parents will forever reside in the walls and the ether around Wisteria Court.

It beckons to me, always.

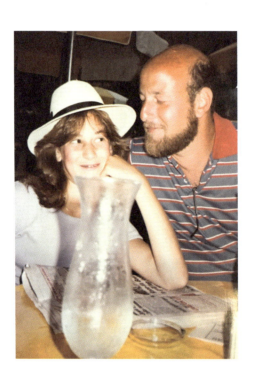

i'm getting my act together

This photograph is so important to me. Despite the unfortunate placement of what was likely an empty "virgin" daiquiri glass, it encapsulates a feeling, a regarding if you will, that you could say has informed everything about me, centered me, and allowed me to regain my balance when it is lost. It's my rudder, my compass. A beacon. It reminds me that on the long list of "things I miss terribly about my dad," one is this: to be looked at in this exact way by him. It made me feel invincible. Adored. Worthy. It was always my true north. It is clearer to me now than the sound of his voice or the cadence of his laugh—both of which have muted over time. It was the thing that we shared. A mutual adoration and respect. An awe. A wonder. A buoyant gratitude that we got to spend this life together, that we were so very lucky to be connected in the way that we were.

It doesn't really matter that the photo was taken on an incredible day in New York City with my forever friend, Lauren Fischel, and her dad, Hal. But the story is pretty remarkable, nonetheless.

We spent the day in the city together, took a tour of NBC Studios, had lunch outside at a café (where the photo was taken), bought some hats we never wore again (also pictured), and then went to see Betty Buckley star in the Nancy Ford / Gretchen Cryer musical *I'm Getting My Act Together and Taking It on the Road*. The show was at the Circle in the Square Theatre in what was then the gorgeously gritty Greenwich Village, a mecca of marvelousness that our fourteen-year-old eyes could barely take in. I sometimes struggle to remember simple things these days, but that night is one I will never forget.

I loved the show and quickly became captivated by its soundtrack. Afterward, Dad and Hal somehow were allowed to go backstage. Implausibly, they invited Betty to join us—including their middle school–aged daughters—down the street at a café on MacDougal Street. Crazy, right?

Beyond bold. But then . . . she actually came. To dinner. With us. No entourage. No bodyguard. Just walked down the street, into the restaurant, and joined us.

I should have been stunned and starstruck, but oddly, it felt so normal and natural that we quickly forgot that this was Betty Buckley. *The* Betty Buckley. We hung out with her for a while and then ended up squeezing her into the back of Hal's tiny car, scrunched on top of me and Lauren, and dropped her off at her apartment uptown. On the way, Lauren confessed my crush on Willie Aames, the actor then starring with Betty in *Eight Is Enough*, and you know, other embarrassing teenage secrets. I can still remember almost everything about those perfect starry hours and what it felt like to be tinglingly alive.

When I look at this picture now, everything about that day comes screaming back into focus—including how lucky I was and just how much I lost. It's an image that makes me simultaneously happy and excruciatingly sad.

This photo is my proof.

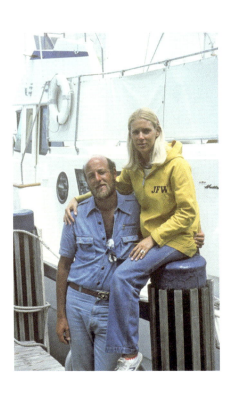

the *tortoise*

My parents' summer parties and that invitation to the orgy party were a not-so-subtle reminder that, in addition to being my parents, they were also multidimensional adults who had all kinds of experiences. They led more complex lives than I could have been (or likely wanted to be) aware of.

Most summers, Mom and Dad, their dearest friends Harriet and Bob Selverstone, and sometimes other close friends like the Swergolds and the Burgers would go on a boat trip to various ports of call around New England. I was never there when they departed on Dad's fifty-two-foot Hatteras Motor Yacht dubbed *Tortoise*, a very slow trawler that he joyfully captained. And I was never there when they returned home. But while they were away, typically for three weeks most Julys, I would receive letters from each of them to my bunk at Camp Birchmont in New Hampshire. The letters would typically share sparse details of where they were and what they were doing; perhaps they would share an anecdote about something funny that happened; and occasionally, they would get more reflective or pensive about missing me or what they wished for me at camp that summer.

Over the years, I have seen countless (and often truly gorgeous) photographs from these trips. In fact, they are so deeply ingrained in my mind that I almost feel like I went on these trips alongside them, that I could share the stories surrounding those moments as if I'd witnessed them firsthand.

But I've often wondered what was right outside the edge of the frame. How similar or different were the moments not captured on film from the myriad others that transpired on these trips? What did they talk about on the long and slow journeys between ports? How many cigarettes were smoked? How much gin was consumed? Did they stay up late talking? Did they play card games? Did they fall asleep at 9:00 p.m., exhausted from a day in the sun, or did they go out dancing? How much did they talk about their kids—their hopes and dreams for them? Challenges faced or troubles unresolved? What

must it have been like for my dad to captain the boat all day, every day? Was that responsibility ever daunting?

Even though these photos were taken while I was away at camp, they were made at a time when I knew my parents and their friends well. It doesn't seem like much of a leap for me to imagine the answers to these questions. But every once in a while, I feel the edges of a bigger story pressing against the border of the frame, and I wish with all that I am that they were here to tell me more.

sugarbush

For several winters in a row, starting when I was eight or nine, we spent most winter weekends skiing at Sugarbush Mountain in Warren, Vermont. My parents purchased a condo there, where we could "ski on, ski off" to the mountain. Each Friday afternoon, after David and I were out of school, our family began the roughly four-and-a-half-hour trek north.

On Friday mornings before school, Mom would ask us what we wanted for dinner from Gold's Delicatessen—Westport's old-school, go-to Jewish deli—so that she could pick up the order before we got home from school and we could be on our way as soon as possible. My standard order was roast beef on a roll with mayo. I wasn't the most adventurous eater then (and am arguably only marginally more so now). David likely had egg salad on a roll, but sometimes he'd ask for chopped liver, the smell of which I couldn't stand. Its strong aroma smelled too much like cat food, and I dreaded the rides when that was his sandwich of choice.

All the car rides back and forth and, frankly, all the weekends in Sugarbush have blended into one or two representative ones. A few patterns stand out. First, *Mass-a-chu-setts.* I guess David was understandably having some trouble pronouncing Massachusetts correctly at the time. I get it, it's hard. Somehow my mom got the idea that using the word as a required password for getting to eat his sandwich would be ample motivation to learn it and get it right. Whether or not this actually worked with any reliability, the association is forever linked in my mind. I can't drive by a "Welcome to Massachusetts" sign without being flung into the backseat of our silver-gray Suburban circa the mid-1970s.

Those were the days without iPods, iPads, iPhones, or iAnythings and streaming on demand. There were lots of hours to fill with simpler, nonelectronic distractions. We played a game where we had to look for license plates from all fifty states and a game where we'd venture a guess and then count the number of red, blue, or white cars we'd see or pass as we traversed a state.

I spent considerable time imagining how much money the government could have saved if they eliminated all the extra green space around the words on every road sign and pondering whether those funds could be put to much better use fixing roads that were badly in need of repair.

Once we passed the Vermont border, we had the option to go one of two ways. The faster route was more treacherous, apparently, and not always open; it was best taken when there were no weather issues or unsafe road conditions. The other route took longer but was mainly paved and always passable. One late Friday evening, my dad unluckily opted for the road less traveled on a particularly iffy night weather-wise. We were far too young to have been clued in to the decision-making. I'm not even sure my mom got to weigh in.

The snow was coming down in thick blankets of white and quickly covered the roads and trees like spray paint. In only an instant, the scene transformed from idyllic winter wonderland to far from ideal. We could feel the car losing its traction, skating from side to side as Dad tried to use the steering wheel to get control. Without much warning, we slid into a snowbank and then into a deep roadside ditch. The car came to a jarring, lurching stop. I don't remember my dad's demeanor at all during the drama, nor his reaction when he realized we were stuck. I'm sure there was swearing in some form. I can be fairly certain, though, that my tweenage self took it for granted that as long as my dad was in charge, I would be safe. I believed that with all of my being, always.

Though she was annoyed by the delay, my mom was calm. Since she wasn't scared, I knew not to be either. As this was pre–cell phones, I can only guess that it was Dad's CB radio that allowed us to call for help. Mom's handle was "Snow Bunny," but Dad's escapes me. It was several hours and a tow truck later before we were back on the road. We arrived at the house well after midnight. My dad never made the same decision at that particular fork in the road ever again.

Details of our time spent in the house or even on the ski trails there are largely gone, though there are little slivers of memory that slide into a thought now and again: trying to ski through a tight glade of trees, missing a turn, and ending up on a toboggan to the emergency clinic; a jubilant but very

short and steep sled ride after a snowstorm, which emptied out into a huge snowbank just above the wooden stairs down to our house; when David took a hundred-dollar bill from my dad's dresser, buried it in the snow near the house, and claimed to have fortuitously come across it when he was making a snowman.

Because the house was a condo, it was virtually indistinguishable from its neighbors. I have a faint glimmer in my mind of the kitchen pass-through and some of the ski-themed poster art on the walls, but when I try to dig in and flesh out the details, the images just disintegrate. I don't think I ever discussed with my parents—at least when I could have—why they chose a place that required a more than ten-hour round-trip commute every weekend. None of that ever mattered. It was just what we did, and doing it together was everything.

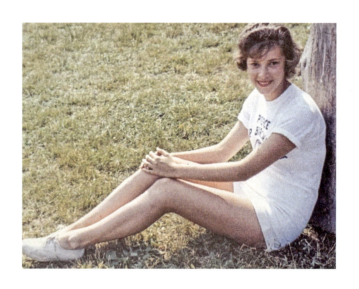

birchmont babe

Pierce Camp Birchmont, on the shores of the tranquil Lake Wentworth in Wolfeboro, New Hampshire, was a home away from home for eight summers. This was true for my brother, who also spent many summers there, and also eventually for my children Michael and Emily. But even more so for my mom. She spent five summers there as a camper and five more as a counselor. It was her happy place in every imaginable way, but also so much more.

Mom started at Birchmont when her dad was still alive and continued her summers there after he died—a traumatic event that was beyond challenging. While the cost of camp was not insignificant and became a financial stretch after her father died, I imagine sleepaway camp was a mutually beneficial arrangement for her and her mother. It provided Mom with some much-needed solace and separation from her newly widowed mother and vice versa. It was both a break and an opportunity for Nanny to grieve and regroup.

The photographs of Mom at camp—of which there are many—don't hint at any inner or emotional struggle. There is no evidence of detachment or sadness in her eyes, save the occasional introverted smile. She never even mentioned how hard it was to cope with the reality of her unrecognizable new life while away for those eight weeks in the summer. Quite the contrary, at least on the surface, camp was pure bliss for Mom, especially as she got a little older.

She was pretty and popular—a beaming blond and all-American beauty who always had a boyfriend and a posse of backup suitors waiting in the wings. She was bright and buoyant, incredibly well suited to life at camp, athletic and energetic, creative and even a little arts-and-crafty, too.

She once recounted gleefully which boy was her sweetheart each summer. These details were somehow seared happily into her brain. It was as if camp really allowed her to be the most present and alive version of herself—to shine ever so brightly in a way that made her feel singled out and special.

Birchmont was a welcome and wonderfully fortifying parallel universe for her, a place where she could literally roam free from the constraints (and any lingering sadness) of her life back home in Rego Park. Birchmont was where her soul and ego were routinely fed the sweetest treats. She was a successful

camper who garnered the "best all-around camper" award—the coveted "Birchmont B"—once or twice. She was also one of four Super Senior girls to be selected as captains in the inaugural Color War, the week-long, camp-wide competition. She triumphantly led the Barker team to victory. As a counselor, she was always admired by her campers and even made a name for herself by cocreating Bagel Sunday, a Birchmont tradition that continues today.

Mom maintained lifelong friendships with old boyfriends as well as bunkmates. She was a favorite of the camp director, known to all as Fosty; his wife, Ginny (Virginia); and all the senior heads of camp, most especially the waterfront director Bobby Spatola and his wife, also Ginny. I can still hear the way Fosty used to say my mother's name. His booming voice always softened for just a brief moment when he said, "Jessie." There was so much love, respect, and adoration always flowing her way.

While David, Michael, and Emily have had their own unique experiences at camp—and not all of them were as uniformly excellent as Mom would have you believe hers was—my time at camp in many ways emulated Mom's. My memories of Birchmont are perhaps the broadest, most intact collection of memories that I have—deeper, richer, more specific and detailed. My summers there are like a home movie playing on a loop. I can dip into a scene from those days in an instant. Easily accessible morsels of memory that never seem to wane or fade. They often provide the visual backdrop for so many of my dreams.

There are enough photographs of my time at camp to fix in my mind how I looked from one summer to the next. These were either taken by me or my friends on a simple disposable Kodak film camera and developed once I was back home in Connecticut or by Dad on Ektachrome slide film on visiting day. I scanned them all many years later. The images also reveal how dramatically I evolved, from a tomboy with style marked by a winged Dorothy Hamill haircut under an orange baseball cap from my Little League team, the Dolphins, to a still athletic, though far more feminine, and slightly boy-crazy teenager.

I, too, had considerable success at camp, at least outwardly: I was chosen to be the Color War lieutenant each year that I was eligible and brought home three Birchmont Bs. Inwardly, I became more and more confident and self-assured over the years. I learned what it meant to be a treasured friend as well as both a team player and a leader.

birchmont babe

But the more I changed, the more things stayed the same. The endless fields, sunburned and straw-like in exactly the same places from year to year, that were as familiar to me as the palms of my own hands. The tennis and basketball courts that were always the same hue of green or black, cracked and buckling in all the same places. The way the limbs of a favorite tree sloped to provide shade in a grove, with piles of pine needles creating a soft nest for a rest. The soft sand on the steep waterfront beach where if you burrowed your feet just a few inches, it was sure to feel refreshing and cool. The somewhat scary, shadowy changing room that we eventually learned to avoid, even if it meant wearing your damp bathing suit all the way back to the bunk. The exact angle of the waterfront trail, up or down, and exactly how many more steps it would take to reach the end. The smooth, slightly glossy finish of the white wooden fence by the volleyball courts. The rust-colored bunk siding and its knotty texture. And always, always, the subtle but intoxicating fragrance of the cool, clean air tinged with pine and pubescent pining. The euphoria of growing up in this big, beautiful bubble of summertime.

Today, a common practice at many sleepaway camps is to post as many pictures as humanly possible of every child, every activity, and every special event so that parents back home can spend countless hours poring over the images. You are compelled to toggle through more than three hundred images each day in hopes of finding the rare closeup of your child with a beaming smile, enthusiastically tearing into a perfectly ripe wedge of watermelon. Or, more often, a glimpse of your child's back running far in the distance on the soccer field, recognizable only because of the particular shirt they are wearing (which you know because you bought it, labeled it with a name tag, and packed it), coupled with the exact shade of sandy brown, wavy hair cascading over their pinny.

I am grateful that digital photography and internet access were still far away in the future during my time at camp. Save for the posed group pictures we took once a summer in our matching, white-collared Birchmont logo shirts and navy shorts, everything that happened at camp was captured only by our mind's eye. Somehow that makes those memories especially rich and, in many ways, omnipresent. Each of them is contained and focused, bouncing around in my brain like air hockey pucks gliding randomly but purposefully millimeters above the surface, speeding up and slowing down, colliding and easily—heartily and energetically—rebounding off everything they intersect with.

fireflies

There are some days that I have to fight like hell to capture a memory. With patience and determination, I set out. I can see it, at first opaque and seemingly just out of reach. I try to collect it and hold it tight.

This process of remembering is like trying to catch fireflies, something I recall doing in the field outside our bunks at Birchmont or in the backyard at North Avenue on an especially warm summer evening. I'd take a big glass Ball jar in one hand and its metal lid in the other and stalk the fireflies quietly with intense focus on a starry night.

Memories, like fireflies, are everywhere and nowhere all at once. Dotting the field around me like constellations. Patterns emerge and then fade. Distance and perspective morph. First, it seems one is hovering right before my eyes. It starts to glow, but then, in milliseconds, the light disappears. It vanishes in a shadow. It takes the memory along with it.

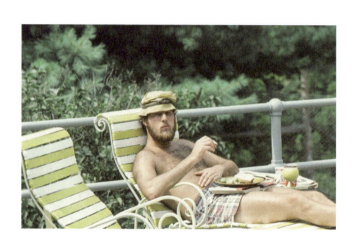

green grapes

You know how grapes don't always taste the same? The green ones especially. Depending on the source, or the exact week of the year, they can taste sweeter or tarter. They can be huge or tiny. A saturated green or a paler one. Sometimes I notice bunches of grapes at the market taste completely different even on the same day.

There is a certain grape that when I taste it, I feel like I am being transported back in time (sometimes I imagine a sound effect like the rewinding of a cassette tape on a Sony Walkman) to our pool deck at North Avenue. My dad is diving into the pool in a paisley-patterned Speedo. It's the middle of the summer, and he is very tan and, as always, very furry. His dark chest hair has migrated onto his back. The air smells like Hawaiian Tropic, SPF unknown. Or likely nonexistent. Always oil.

When I happen upon that exact grape—the one that tastes like my childhood—it makes me so happy.

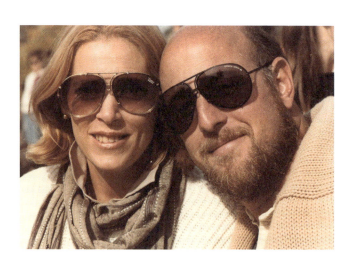

college days

On September 16, 1984, I was a brand-new, two-week-old freshman in college when this letter arrived from my dad, written on his warm, Dijon-mustard-yellow personal stationery with a mod, stylized "MHW" monogram blind embossed and floating on the top of the page.

Hi love,

It's Sunday afternoon, 5:35. We've been packing and getting ready to move out. I'm exhausted, both emotionally and physically. I'm excited about the new house but sad to leave North Avenue. I have so many good warm memories of the last 10 years—of growing up—sharing—summer days—big parties—of feeling good about myself and the environment I made for the family. I hope the new house provides the same warmth and security, comfort and pride as North Avenue. Enough about houses, for now anyway.

Let me share with you my feelings about my daughter. Stacy, you are one of the most wonderful parts of my life. I look at you, watch your reactions, your joys, sorrows, thrills, laughter, sense of humor, sense of life and thank God for creating this wonderful offshoot of mom and myself. The amazing individual you have become and will grow to be gives me so much joy, pride, happiness, warmth, and missing that I can't begin to truly comprehend how important you are, how much I miss you, and how proud I am to miss you so much. When I was growing up (just the other day), people would speak about their parents with negatives. I remember all of the good feelings, caring and love, of giving and protecting, of family about Grandma and Papa and Ann. I hope—no, I really know—that you will always have loving feelings about us. That is a great tradition to pass on, a sense of family and a sense of security as a part of being a member. I miss not sharing with you every day. I miss not seeing and hearing your voice. I guess this is the beginning of a new era of family growth, of my daughter and myself. I know it will be as wonderful as the last 18 years. For now, that doesn't make missing you any less aching, but it does make loving you one great feeling.

Love, Dad

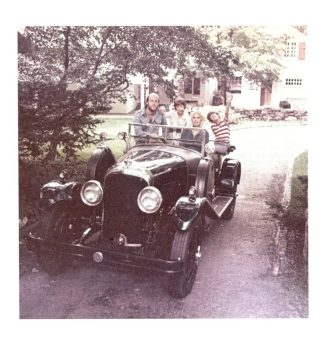

home, again

The memories arrive like clouds passing overhead—sometimes faster, sometimes very slowly. Sometimes full and fleshy and robust, other times wispy and transparent. I am grateful for every one.

I try to be open to receiving them. I let them settle and tickle my consciousness instead of swatting them away. I always hope they will lead me somewhere new or previously forgotten, but that doesn't always materialize. Occasionally, I get sidelined by the reality that I will never remember more than I do now, only less. And less. But when I am certain that a memory can be only that and not an elaboration built from a photograph I'd once seen, it's especially satisfying and feels somehow more important, too. When that happens, I try my best to fix it there—somewhere contained and protected, so that I can return to visit it again and again.

Oftentimes, a series of memories will present themselves when I am driving. The white noise of the road rumbling beneath me creates that space for them to coalesce. This happens frequently when I am in my hometown and the muscle memory magically guides me from place to place without even momentarily thinking "How do I get to . . . ?"

When I am driving close to my childhood home, this is even more pronounced. It's almost like tuning an old-style radio with a dial. There are whirring sounds and static and then, finally, a pure and clean connection. Unmistakable clarity.

A few years ago, our daughter Lissy and her husband, Alex, started building a house quite close to that childhood home of mine and one street away from where I went to elementary school. Inevitably, when we'd go to a site visit, childhood memories would start to percolate. I could see myself walking up the steep hill to our house after school and feel the weight of my backpack slowing my gait. I could taste the anticipation of getting home, being home. Just home. Wisteria Court called to me in a way that no other place really has. And it still does.

One day, Howie and I were driving past the house after we stopped to see the progress being made at our kids' place. As we approached the top of the hill, I felt I had to turn in.

"Please just go down the driveway," I said.

Then as Howie got ready to turn right, a car approaching from the other way stopped across from the entrance and signaled they were turning in. We abruptly, hopefully unnoticeably, abandoned our plan to avoid having to explain who we were and why we were trespassing. Instead, we just continued past the house. The disappointment echoed in my head until Howie offered, "Maybe it's a sign that it's time to let it go, pass it by." Perhaps exactly that. And yet . . .

I have a vague memory of mentioning the importance of sharing family dinners each day and commenting that my dad was home for dinner each night. My mom interjected (or perhaps she told me later?) that this was not the case. Apparently, he was sometimes home for dinner, but mostly not. This fact didn't square with my memory.

I struggled to reconstruct it in my mind to prove to myself that I still had it right, but in the end, I settled on something that is perhaps more interesting and emblematic of how our brains remember things. The memory that my dad was always home for dinner grew from a sensation that he was there, emotionally. He was always there for me, even if he wasn't physically there. To my mind, the foundation that he and Mom architected and built to support my childhood, my self-esteem, and my psyche was airtight, impervious to cracks or leaks or even settling. And somehow, the aura of that comfort still lives on in that home. In his absence, it pulls at me even more.

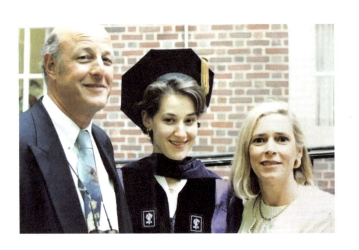

moving up

Dated May 14, 1993, this is a letter from my dad on the occasion of my law school graduation, written in his chicken scratch scrawl on the back of the commencement program.

My dearest daughter,

All your life you have brought me so much joy, happiness, pride. Your successes have provided me with a constant stream of vicarious pleasures. I take your success as my own—and of course Mom's and David's and our close family. Stacy, I hope this accomplishment is a rung in the ladder in your growth and journey through life. I truly believe that you have something special to give those around you. The tools that you've achieved up to now in your schooling will give you a huge advantage to make a difference.

Throughout my life I've given very little to anyone beyond a small group. I consider myself successful, and I'm proud of my accomplishments. I hope that your advantage will let you impart the good to a wider circle and your children to an even wider one. But most important to me is that you will be happy and self-fulfilled.

Stacy, you are a beautiful gem in so many ways. Don't let the world scare you. Challenge it with the same devotion you took on your studies, and you will achieve the same success as you grow up.

I love you so very much.

You have made me very proud today and for the last 27 years.

Congratulations, Lawyer!

Love, Dad

Mom, too, was jubilant on the day of my law school graduation from New York University. I think it brought her relief to know (or at least to think) that I now had a clear path forward careerwise. An official launch, if you will.

She once told me how overwhelming it sometimes felt to her when my path was anything but straightforward. The options and possibilities were so much broader for women of my generation, and that created too much uncertainty for her liking. And yet, despite her discomfort, she never strayed from being thoughtfully supportive and endlessly, selflessly encouraging, even when I inevitably hit some bumps along the road. I was consciously grateful for the freedom I had to explore and unearth my passions. I felt her confidence that I would one day find my path forward.

block island

In the fall of 2017, Block Island beckoned. It was a place I never intended to go back to, its mere existence ignited such anger—rational or not. For the longest time after the accident, whenever I saw cars with a black-and-white "BI" sticker affixed to the rear windshield or bumper, I felt accosted. I felt irritated and annoyed that people weren't more sensitive, absurdly musing to myself, "Why should I have to drive around my hometown and be subjected to that marker?"

That feeling took fifteen years to diminish and was replaced with a quiet but robust dislike, a persistent feeling that there was nothing redeemable about that place thirteen nautical miles off the coast of Rhode Island. I had no reason to ever go back. Until . . .

My longtime client, Jill O'Shea, a brilliant and incredibly talented interior designer, had a project on the island. She mentioned it once she started working there and suggested the possibility that I might consider photographing the property for her one day in the then-distant future. She knew that Block Island was highly charged for me and that it might not be possible. Though I said I'd think about it, internally, I had already dismissed the idea. I couldn't see how that voyage would lead to anything more than aggravating layers and layers of trauma.

About a year and a half later, the project on Block Island started to feel like not only something I should consider but also something I needed to do. Perhaps going there could offer some clarity or closure? I reasoned that *if* I ever were to go back to Block Island, having a reason to be there, a professional, nonemotional, and focused reason to be there, was the only way it would happen. And so, I said that I could and would photograph her client's property. A date was set, and then I waited for it to be canceled or postponed, for a sign that I shouldn't go through with it, for something urgent to deter me. But that never happened.

On October 10, 2017, I packed an overnight bag, loaded up my equipment,

and set out toward the ferry terminal in Point Judith, Rhode Island. I picked up my new assistant, Chris, along the way. During the drive, as Chris and I got to know one another, I decided I should share what was happening with me—the unique circumstances of this shoot—and admit that I was unsure exactly how I would feel or what I would be able to process once we reached the island. In short, I wanted to explain to him that I might need more support than usual for a typical architectural photography outing.

Sharing my fears, however, actually intensified them. I felt unstable and somewhat ill for the remainder of the drive, which is not the best way to embark upon a ferry ride that is notoriously nausea-inducing. As we boarded the ferry, I took the deepest breath I could muster and tried to hold back the tears welling up in my throat. I hoped I hadn't made a terrible mistake and feared that I could be wasting Jill's time, effort, and money in preparing her project for the photoshoot. I did my best to steady my nerves and subdue the panic. And then, we were underway.

I allowed myself to roll along with the ocean beneath me, absorbing the waves crashing up against the boat and the loud and constant churning of the engines. I tried to focus on my purpose and center myself with my work. I was determined to be professional at all costs. The afternoon sun was still strong and warm inside the ferry's cabin. I sat beside a huge port-side window, bathed in the blinding light, and talked to the heavens with my eyes.

As the ferry pulled into the terminal, I was relieved to receive texts from Jill outlining some logistics. I could attend to those easily and distract myself from the upcoming landfall. This worked, and I was able to disembark onto the island without breaking down. As I drove across the island, I felt as though I was in a slightly altered state, taking in glimpses of the nature around me. I felt the ripples of some perforated memories from when I'd been to Block Island several times in the years before the accident.

My mind vibrated with disconnected pieces of news stories and fragments of my imagination: "Plane Hits Block Island Restaurant, Killing 5" and "Small Town Tries to Get Over Shattering Plane Crash" in *The New York Times*, "4 Die as Seaplane Slams into Car, Rhode Island Restaurant" in the *Los Angeles Times*.

The official summer season had just ended, so the island felt somewhat

unpopulated—quite the contrast from the peak of tourist season. It felt deserted. Almost eerily quiet.

When we arrived at Jill's project just a few miles away, I was happily swept up by my job. I reviewed the project with Jill and came up with a shooting plan for that evening and the following day. I set up my camera and started to shoot. We were losing light quickly, but the sky was gentle and beautiful, caressing the house with a warm pink hue. The seagrasses whispered in the wind, lightly brushing the shutters. The pictures calmed my nerves. The focus and creativity wrapped my mind up in a soft, padded blanket, and I was somehow OK. So far, I was actually OK.

Before the very last sliver of light disappeared from the sky, we drove to the lighthouse at the end of the island, watching and waiting as the sky turned a bright and bold orange. The lantern room was intermittently aglow, offering a beacon to those at sea—a path forward, a safe haven. I felt it, too.

Heading into town from Corn Neck Road on our way back to the inn where we planned to spend the night, something stirred in me. My skin erupted in goosebumps and full-body chills. Sure enough, when I looked to my right in the post-dusk night, I could just make out the shape of a gas pump in the middle of a driveway, tucked behind a building. It was the kind you'd see in the 1950s, silver and rounded. Then I just knew.

Back at the inn, I googled the address and confirmed what my visceral reaction already signaled. This is where it happened. This very place.

I knew from the news accounts that the plane had crashed into a restaurant, which also had a gas station connected to it. Both were engulfed in flames on impact.

To add to the tragedy, an older woman, Vera Sprague, aged seventy-nine, was filling her car at the pumps when the plane came down, killing her instantly. I also learned from the papers that Ms. Sprague was the mother of the island's fire chief, "a well-loved and respected woman." She was described by someone to *The New York Times* as "one of the clocks who make this place tick."

For more than twenty-two years, I had reconstructed Darcy, Glenn, and Dad's last moments on earth in a certain way. Using news stories from the accident and personal accounts sent to my family from those who had

witnessed it, I created my own memory of what happened there. The "what" but also, in parallel, the "why" and the "how." I imagined a quiet harbor on the far side of the island, open to the sea on one end and bordered by a beach, cliffs, and dunes on the other. It is this place that provided the backdrop for all that I imagined—a film version of the accident, if you will, that I wrote and directed in my mind and projected onto the inside of my eyelids.

I now saw that my little film was very wrong. The flickering images representing the scene of the crash didn't match reality at all. The visual I'd created was more Irish seaside than this tiny, flat New England island. I wasn't prepared to have that image dispelled. I had never planned to actually locate the scene I had dreamed up, the site of my waking nightmares. I couldn't see any reason why I should revisit the scene of something that was so painful and endlessly complicated. I was sure that doing so would generate new visions and new nightmares.

That night, I struggled to fall asleep. I was tormented by this new information and the reality that the exact location of the accident was only a short walk down the road. Eventually, I lapsed into an uneasy and fitful sleep but awoke, convinced I needed to go there. After coming all this way, I was sure I had to put myself in the place that took their lives—the place where they took their last breaths. I wanted to retrace their path, stand under that sky, and feel the ground just there. Exactly there.

On the way to the photoshoot the next morning, Chris and I pulled over. I got out alone and walked the path toward the dune, beach, and harbor. It was so very different from what I had imagined, but it clearly matched the descriptions I had read. I never thought I would have the strength to go there. That I would *ever* be there, but there I was. It's hard to describe what I felt like in that moment. Suspended. Connected. Lost. Found. The sky was growing moodier and dark, unlike the vibrant sunrise earlier. I felt acknowledged and angry. Sad and bereaved. Scared and alone. But also improbably strong.

I climbed up the path and over the dune onto the beach below. I replayed the movie I created in my mind about what had transpired and imagined a conversation between my dad, Darcy, and Glenn. And also Leo, Glenn's friend who had joined them. Were they afraid? Did they panic? Apologize? Reassure

each other? All these years, thinking about their last moments—the unknown and terrifying abyss before them—has been the most torturous part. Knowing the depth of the relationship that existed between them. The trust, the caring, the love. That part—then, now, always—still tears me apart.

Part of me wanted to stay in that spot. For a while. For some hours. Forever. To let it all wash over me, again and again. Perhaps if I lingered, I could gain some spiritual connection with them through the earth, at that precise location. But another part of me knew that I had to move away, to leave it behind and embrace the present day.

Stepping back toward the car and the day's assignment, I said a quiet goodbye in my head. And then out loud, my voice growing louder and more confident with each word.

"I love you all so very much. I miss you terribly. You are remembered. Every minute of every day."

As I write this now, tears are flowing down my face, but on that day, surprisingly, nothing came. My voice was clear and strong. I walked right up to that moment, and somehow, I made it to the other side.

The rest of the day was uneventful. I was able to focus on my work with enthusiasm and purpose. I gave my very best to Jill and honored what she had created there: a gorgeous family home on a faraway island in the middle of the sea. We finished the shoot in time to travel on standby on an earlier ferry back to the mainland. It was then that I started to feel overwhelmed by where I was and eager to get off the island. For several hours, Chris and I waited in line, hoping to be granted a spot on the oversold reservation list, as the island grew ever more deserted and the season began to change. Finally, we were cleared to drive aboard.

After parking the car in the berth of the ferry, I made my way to the upper deck and waited for our departure. I felt the swelling of the seas underneath us and the swelling of my tears. I quietly heaved. Just as we pulled away from the dock, my cell phone rang. It was my son, Michael, who often knows intuitively exactly when I need him. In that moment, I felt the full weight of what I had just experienced. The loss, the longing, and the enormity of this particular goodbye. I was leaving them behind. Torrents of tears fell.

To: The Family of Michael Waldman, Surf Road, Westport, Connecticut

From: Ron McKeown

Date: August 30, 1995

On behalf of my family and myself, I wanted to write to offer my sorrow on your recent tragic loss. My family, and my friend and his family were perhaps the clearest witnesses of what happened in that we were on the beach, in the water, and saw every moment of what happened. Clearly many of the news accounts were incorrect.

From our immediate reaction, we felt and verbalized to each other that the pilot acted heroically in risking his life for the large numbers of people on the beach. It was always clear that he was landing his plane, perhaps in an emergency/needed setting. When he approached the small infant of my friend, and the rocks which were evident, and then the other small children immediately following—the plane lifted with all regard for the swimmers and little for the plane itself. The pilot then had a decision to go into a telephone pole and a house which had a very visible lady on the porch or to turn, which he did tragically.

I am not sure that this is the view that you have received to date as many views appear disjointed and wrong. I wanted you to know that from our perspective, Mr. Waldman's actions were heroic—and done consciously. I am glad that Mr. Waldman had the qualities of courage, sacrifice, and honor. May god bless you and your loved ones.

From time to time, I allow myself to fall into a virtual rabbit hole. I google the accident in search of a previously missed detail or something that might paint a fuller picture of what happened that day. A few years after the accident, I somehow connected with a local Rhode Island TV station that claimed to have footage that would offer some clues. But in the end, it taught me nothing.

There was news coverage on CNN that day and several articles in local, regional, and national papers. They each recounted the basics. A private seaplane had crashed. There were five fatalities. But none of the reports offered any real insights. At some juncture, I was able to see and read an FAA investigative report that showed the plane was operating correctly and weather was

not a contributing factor. It was an accident in every way—unintentional, unprovoked, and apparently unavoidable.

I often consider that if the accident had happened today, in 2025 instead of in 1995, so much would have been different. No doubt, we would have been in constant communication with Dad, Darcy, and Glenn throughout the day by cell phone or text. I might have intervened to suggest they come directly home instead of diverting to Block Island for lunch. I would have reminded Dad that it was Auntie Ann's birthday and that getting home earlier would be advisable and certainly much appreciated.

And if none of those things would have actually changed the horrifying outcome, surely there would have been countless bystanders, smartphones in hand, filming every instant and unable to look away. Perhaps then, some element of the vast unknown would become clearer to me. I wish for that sometimes. For the relief it might bring. And then wonder if that reality might be even worse than all that I've imagined.

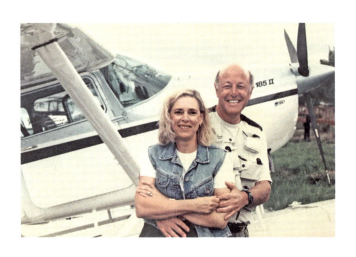

take flight

In the earliest years after the accident, I struggled with fear—specifically related to flying, but also more broadly about anyone I knew not returning from wherever it was they were going. There is a part of me that relishes being in the air in that way, above the clouds, where the plane levels off and the engines quiet a bit. With endless skies ahead and the never-ending Rorschach-like clouds, I feel closer and more connected to my dad and cousins. And yet at the same time, the flight can dramatically compound the constantly looping disaster film that plays in my head and graphically depicts their plane crashing. And crashing again. Each take is slightly different yet eerily the same. Driven by raw emotion and overwhelming grief, my attempts to obscure or black out the vivid flashes of the fire are futile. Explosions unfold in my brain in slow motion. The crackling, angry red, yellow, and orange flames roar at me, untamed. Again and again.

In time, I taught myself to appeal to logic in order to slow down the film, to edit out some of the most gruesome parts, to fictionalize the reality and thus put some distance between it and me. The odds were in my favor, I reasoned. Right? Wasn't it unlikely that I would die in the same way? That would be crazy. Unheard of. Right? It was as if I'd negotiated a deal with the universe, and in exchange for the excruciating loss I suffered (though it's no consolation), I would get to fly safely, now and forevermore.

Eventually, I started to develop a ritual that helps mentally prepare me whenever I have to fly—and that somehow assures me it makes all the difference to the success of the flight. Just before I board the plane, regardless of how many people are waiting behind me and despite that invisible push to move forward, I stop for a moment. I place my right hand on the usually cold fuselage so that my fingers can feel the raised metal rivets next to the boarding door, and I say a short prayer to myself. I move my lips noiselessly as the flight attendants look on curiously, intoning a few words that serve as an

affirmation and query to my dad: "Please, *please* let everything be OK. Please let us arrive safely. I love you."

As much as I wish such deals were both possible and enforceable, and as much as I know that they aren't, this ritual is enough to supplant my fear, for a little while at least. On a smooth flight—when all seems to be working perfectly, the plane pushes back from the gate on time, we're in the air on or close to schedule, the tailwinds are in our favor, and the weather is clear—I can manage to almost relax. I try to forget where I am and distract myself with a movie or music. Or a stack of magazines. And I can be OK. On longer flights, when my mind drifts to the miraculous idea that a huge hunk of metal with hundreds of people aboard is transporting me to the other side of the world, I sometimes watch the little white plane graphic as it progresses over the world map, and that calms me. The metrics soothe my nerves. Distance from origin. Time at destination. Remaining flight time—my favorite. Refresh. Refresh. Refresh.

But when things don't go as smoothly (or worse) and there is turbulence, all bets are off. Reason and logic disappear instantly. With my stomach in my throat, my mind reels again. The all-too-familiar film starts looping anew. The fear thunders back. I try to remind myself that the odds are overwhelmingly in my favor and of the deal I struck, but in those moments, the only thing that really gets me through is complete resignation. I have to give in to the worst that could happen so that anything short of that is a relief. In any case, it's out of my control. If this is my time and the plane goes down, so be it. Maybe then we can be together again.

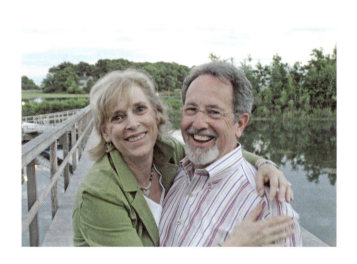

the personals

I know now with certainty that no one ever knows what is going on in someone else's home, much less in their marriage. No matter how much you think you know, you don't.

From my unsophisticated perspective growing up, it was obvious that my parents had a happy marriage. They regularly and easily expressed affection and love toward one another. Their connection was palpable. Even as I've matured and had the benefit of more experience and more relationships of my own, I still believe that theirs was a happy marriage at its core. Whatever shortcomings or challenges they faced, Mom and Dad were nonetheless truly content to be together for whatever came next. Whether it was a celebration or vacation, an adventure or unexpected change in life's direction, or just regular days ahead.

I was so out of my mind with my own grief after the accident that I wasn't as attuned to the true depth of the loss my mom was experiencing. She had lost her husband of thirty years, the only man she was ever with, and faced an unknown and potentially lonely future without him.

Mom was only fifty-two years old and very much full of life. A romantic through and through. Why would she want to face however many years more she was fortunate enough to have without a partner to embrace them with together? She coincidentally met Carl in a bereavement support group at the hospital, and they became friendly. However, it was some time before their relationship morphed into something more than friends, one that would endure. In the meantime, Mom decided to put an ad in *New York Magazine* because it was one of the more proactive things you could do in 1995 when looking to meet someone compatible.

Back before the world had gone fully digital with dating apps like Tinder, Hinge, Bumble, Match, and JDate, the weekly print edition of *New York Magazine*'s "Strictly Personals" was the gold standard for dating. In fact, reading the listings was something of a sport for me. Even though I wasn't

"in the market," it was still fun to see who was out there. I enjoyed trying to decipher the acronyms people used to describe who they were and who they were looking for. It was interesting and amusing to see how creative, funny, and clever people were. Back in my early twenties, I never considered I might one day be crafting a personal ad, or even more bizarrely, that it would be for my mom.

At the end of every ad were the letters "NYT" and an ID number that interested suitors were required to highlight on their inquiries. Then every couple of weeks, or when there was some sort of critical mass, the assembled letters were mailed off to the match-seeker. None of us were at all prepared for the number of lengthy, handwritten letters that arrived seeking a date with my mom. It was surprising, to be sure, but to her, it was both astounding and overwhelming. How would she possibly decide how to proceed? What would or even could happen next?

One weekend, cozied up on the couch at the Windham house, we dumped out the pile of responses and pored over them together. Mom was a mixture of giddy and trepidatious. She was flattered and pleased that her description was compelling enough to warrant such an enthusiastic response, but she was also wary of going on a date for the first time since she was twenty years old. Every element of the letter—from the chosen stationery and the handwriting to the postmark and the theme of the stamp—provided clues about the suitor. We read them aloud and were sometimes forced to decode hieroglyphics. We stopped occasionally to giggle about a funny word choice, turn of phrase, or misspelling. We disregarded the ones that felt completely off or uncomfortable, which was the equivalent of swiping left.

In the end, there were a few that were decent and warranted a response and to which she ultimately replied. This yielded a date or two. One guy even earned a second or third date. Maybe it was Alan? Or Mark? Maybe Richard? Those details evaporated long ago.

It was still really hard. I wanted to support her excitement and even share it, but it was challenging to fully disconnect from the fact that it was the accident that put her in this predicament in the first place. More than once, Howie and I made plans to eat at another table at the same restaurant during one of her

dates so that we could monitor what was happening (e.g., come to her rescue should the date go completely wrong or if she was just too uncomfortable to proceed). The entire thing made me anxious, both in the sense that Mom could end up in danger of dining with a crazy person and because there was something off-kilter about me, her adult daughter, supervising her on a date. Another ripple of the accident was that the natural order of things was now quite unnatural.

On the one hand, I wanted her to find someone wonderful with whom she could spend her days. As much as she was always welcome and encouraged to stay with me and my family or David and his, Mom was steadfast in her belief that she could and would not be an appendage to our lives. She felt she needed to build a new one for herself. While it was hard to argue with the no-nonsense practicality of her perspective, it was equally heartbreaking to process the challenge before her.

Ultimately, and gratefully, after a bit of back and forth, Mom and Carl made their way back to each other and decided to make a go of building a new life together. Carl's first wife, Sharon, whom I had heard such wonderful things about, had passed away from pancreatic cancer around the same time as the accident. So in addition to being able to offer an unusual level of empathy and compassion to each other, they also shared something less typical: They were coming together as a couple when neither one of them had chosen to end their previous relationship. They were attempting something fragile and difficult—opening themselves up to falling in love again when they were each still happily in love with someone else. Even now, that seems to me a herculean, incredibly complex task that requires extraordinary emotional strength and control, but they made it work.

There were many inflection points along the way—for them and, frankly, for me—that weren't anything close to easy. They had to decide where to live and how far that would take Mom away from us and her grandchildren. Carl had to overcome what I think he perceived as an insurmountable obstacle: that I could never accept him as a replacement for my dad, whom I adored and continued to mourn very intensely. In time, he came to realize that I had the capacity to welcome him and still miss my dad terribly at the same

time. And I came to appreciate and be ever grateful that my mom was given this second chance at love. How much deeper and richer her life was because of it.

While Carl was a warm, caring, accomplished, and gentle man, there is no doubt that I puzzled over just how different he was from my dad. Though the choice to be with Carl was undeniably a solid one, in some ways, it seemed incongruous and hard to reconcile.

During a brief interlude at one of my kids' birthday parties, I had an unexpected conversation with my mom. The kids were probably around four and six, and we were sitting on a mudroom bench that had temporarily found a home in the playroom. Without any provocation and completely off-topic, Mom said, "I can't tell you that if your father came back that I would leave Carl to be with him." I was stunned by this admission, in particular, because there was no coming back for Dad. It was also strangely validating—perhaps I was not the only person holding out some ridiculously placed hope that Dad might have survived the accident and was amnesic, living somewhere in Rhode Island and unable to remember he had a family that was missing him terribly. At the time, it felt like an unnecessarily hurtful thing to say. Especially to me. What possible reason would there be to recast the realities of their marriage? Perhaps it was better to just let it be.

Later, when I had some time to digest her comment, we had another conversation. Mom shared that as much as she loved and was in love with my dad, there were elements to life with him that were very hard for her. She was often out of her comfort zone as he continually planned and pushed for new adventures. He was always moving, shaking, doing. Looking for new opportunities and bigger or better pursuits.

Although she appreciated the finer things in life, Mom came to them from a far simpler place. She could enjoy them but never needed them. She was content to slow things down a notch, or five. To stay and not go. To read and not ride. And the cadence of her quieter, simpler life with Carl was a huge relief. A chance to just be. And be in love. And this made her infinitely and visibly happy.

national hall

As the eighth anniversary of the accident came into view, I reflected on my grief. Though I was seemingly productive and present, my anguish surfacing less and less, the undertow it created could still be overwhelming. I felt I needed to wrangle my emotions if I was truly going to move forward. Howie and I decided it would be a good idea for me to go away somewhere quiet, but not too far removed, to spend the time facing these daily demons. I opted for a room at the Inn at National Hall, then a surprisingly luxurious boutique hotel in Westport. It was also the very same hotel where we'd spent our wedding night in May 1997.

I decided to spend my time there writing a letter to my dad. I believed the act of writing it down, committing my thoughts in my own hand to a yellow legal pad, would help me to better process them and would further catalyze healing. It would be like signing a contract with myself, acknowledging the changes I thought I needed to make in my life, and binding my actions moving forward. And so, I began.

Until one is committed, there is hesitancy,
The chance to draw back, always ineffectiveness.
Concerning all acts of initiative (and creation),
There is one elementary truth,
The ignorance of which kills countless ideas and splendid plans:
That the moment one definitely commits oneself,
Then Providence moves too.

All sorts of things occur to help one that
Would never otherwise have occurred.

A whole stream of events issues from the decision,
Raising in one's favor all manner of unforeseen
Incidents and meetings
And material assistance,
Which no man could have dreamt would come his way.

160 lightkeeper

I have learned a deep respect for one of Goethe's couplets:
"Whatever you can do, or dream you can, begin it.
Boldness has great genius, power and magic in it."

—W. H. Murray, *The Scottish Himalayan Expedition*

August 25–26, 2003

Dear Daddy,

Today is the day. It simply has to be. It's time to find a way to embrace life without a barrier enveloping me and relish all of the joys that exist in both the everyday and the momentous. I have been so tormented and in pain, and sad and angry and depressed by all that has happened stemming from that single moment on August 26, 1995, when our lives were inextricably changed forever.

I know and believe that you can see what has happened—the choices we've made, the highs and lows we have experienced, and what remains of our family. You were the center of everything—the pulse, the spirit, the energy. Not just of my life but of our extended family's. The circumstances of the accident and the stunning coincidences of fate have created such intense complications and contrasts—many of which are at times unbearable, seemingly impassable.

Auntie Ann and Uncle Sid are virtually unrecognizable. Of course they are. There is so much pain and the intensity—still—always—of their anger is excruciating. I have tried to stay connected—torn between a feeling that you would have wanted that and the fact that there is so much hatred toward you that staying connected sometimes feels like a betrayal. I think Auntie Ann wants me to continue to try, but she offers no real hope that we can ever resurrect any semblance of the relationship we once had. Too much is lost. Uncle Sid has emotionally disowned me (and Mom and David, too)—not able to bear the connection and, more importantly, that I dare to love and miss you as I do—in spite of the responsibility he places on you for all that they lost.

What happened is so horrendous. Unimaginable, really. Perhaps that is why I have been unable to fully move forward in a meaningful way. I look for answers, and there are none. I'm not sure what good it would do anyway, since most times, anything short of reversing time and bringing you all back feels

national hall 161

woefully inadequate. I still think about those last seconds and am tortured by what you must have thought and felt—about us, about Darcy and Glenn and Ann and Sid and Granny and Papa and the endless ripples that would surely follow. And have.

The feeling that you had to have been frightened and terrified and helpless is almost impossible to digest. I worry and think more about what was happening emotionally on that plane and the dynamics between you and Darcy and Glenn than about the physical pain—believing it was instantaneous—and my imaginings have caused much agony. Ann and Sid surely wish and dream . . . that it could have been me and David instead of Darcy and Glenn—more fitting that you should have taken your own children with you. Early on, I know I thought that, too. Even in a moment that seems relatively OK, it's hard to shake the feeling that whenever Ann looks at me, all she can really see is the absence of Darcy. Like I am the anti-Darcy. And it takes all of her strength not to reach out to strangle me or to scream as loud as she possibly can. And as cruel and distressing as that feels, I also understand it.

I am sure you know how tortured Papa was by all that happened—he never recovered—really at all—and was so startlingly fragile from that moment on. I miss him terribly and so hope in my fantasy of the afterlife that you are somehow together with him, and Darcy and Glenn.

The circumstances of the accident were such that the ability to grieve for my cousins is largely unresolved. When I was a teenager, I felt jealous of Darcy in many ways at different times, and in particular, despite how close you and I were always, I had a hard time with the special bond you also shared with her. I am so grateful that Darcy and I had a chance to reconnect as we got older and sift through some of what we felt growing up together. Perhaps it is that emotional reconciliation that makes her loss more painful and uncomfortable for me. I adored her and was so looking forward to increasing our closeness as we got older. Another plan. Another dream. Taken away.

The never-ending ripples. There are so many connections to what happened that I seem to slam into retriggering events and moments constantly. Not just obvious ones like birthdays and anniversaries but knowledge of other losses, meeting someone out of the blue who recounts a story or shares a feeling he or she had about you—all act to re-create a longing and to reinvigorate the suffering in my heart.

I am trying to find a way to modulate my reactions. To transcend the grief and

find a way to embrace the future and what I can learn from what has happened. Most days, this seems unachievable, but lately, I have begun to feel that being able to do so is critical to my existence. And for the sake of myself and my family, I forge forward.

Maybe you already know I have an extraordinary husband. I know that you met Howie—albeit briefly—and I know how you would surely have loved him. He is warm and loving, engaging and charismatic, dazzlingly smart, gentle and kind, generous, committed. Perfect. And I feel sometimes that I am being unfair to him each day that I am smothered by the absence of my father. He deserves more than that, and our marriage needs some release from the pain and sadness if it is to flourish and grow. I know you would want that for me, too.

I also have these unbelievable children. Michael and Emily. They are each brilliant, bright lights—even at this young age, you can see that they are lit from within with passion and purpose. I am grateful every minute of every day that they are mine. I know you know them and can feel them, and miraculously, they feel you, too. I love them so much it hurts sometimes. Because I am sad that you and Mom are not in their lives in the way I always dreamed, I am trying to reconcile that dream with the reality and accept what is. It's hard to do. I sometimes fear that I haven't been there for them in the same way I would have been if you were still here. And. And. And. I sometimes feel (even slightly) aloof and distant, and it is so painful to think that I am letting them down by not being present—fully and completely. I so want to enjoy all of the time I have with them, to be there with them—in the moment. For as many moments as I can. I commit to doing that—right now.

I know how proud and adoring you would have been of these kids. They are startlingly perceptive, warm, loving, sweet, funny, gorgeous, full of life. They are each like you in many ways—spirit and intensity abound. And that twinkle in the eyes. Knowing. Mischievous. Fearless at times. I hate that you are missing that, that I am missing seeing you with them and what we all could and would have shared. It all feels so unfair.

I have two "stepchildren," too, as you must now know—though from the very beginning, that moniker has felt misplaced. It's been a challenging and often complex path to find my place in their lives. But I do my best daily to quietly acknowledge that while I am not their mother, they are nevertheless my family in every way that matters—just as Michael and Emily are—and that I am devoted

to this blended family of ours in every way possible. They are "our" children—all four of them. It's easy to see how naturally the four kids are connected and how much love flows effortlessly between them. And for that, I am ever grateful. I promise to always try to create an environment such that those relationships will continue to grow and grow, unbounded by pure biology.

Mom is happy again now. She seems settled and in love with Carl—a man more different than you than conceivable. But such a very good man who treats Mom with loving kindness and generous care. And I am happy for her. I still find it difficult when I think of what might have been, but I am trying to rise above that and be purely grateful that she is surviving and thriving and not alone.

I am so tired.

I will write more in the morning.

Perhaps tonight you can come to see me. As you did once before in this very place. Goodnight, Dad. Goodnight, my daddy. I love you.

It's 8:00 a.m. on August 26, 2003. It has been eight years since the accident. Seems unbelievable, as images are still as vivid as they were so long ago. The sky is clear and crisp and perfect. Just as it was eight years ago and, if I can recall correctly, every year on this date since. Today it speaks of clarity. Time to start fresh. Time to lift those clouds and the weights on my shoulders. Time to reembrace life and each new experience with newfound energy and intensity so as not to miss a single precious moment. I know I will falter at times. I expect to. But for the first time, I feel a commitment to do this, and I know this is what you would want for me—what you always encouraged me to be and do.

Last night, I reread many of your letters to me. Some from when I was at camp, at college, at my law school graduation, on Valentine's Day. All milestones in some way. All crossroads. And each time, you were there—as you always were—to give me guidance and love and support—unerring and perfectly placed. I can still hear your voice in my head and have your love in my heart, and now, I will try to use those tools to give me strength and dedication and focus—rather than a dull ache and longing for what once was.

I never imagined, I never feared that my worst nightmare could come true

and you and Papa and Darcy and Glenn and Ann and Sid would not be physically present to witness and soak up and, yes, applaud, the milestones we are experiencing these days. My turning thirty. Getting married. Having Michael. Having Emily. Turning thirty-five . . . and on and on. It changes the shape of those events in a way I never expected, but those moments are oh so sweet and special and once in a lifetime, and I don't want to miss them, too. Bar and bat mitzvahs. Graduations . . .

It is strange for me in many ways that my family—Howie, Lissy, Benji, Michael, and Emily—don't know you or enough of you, and I often feel alone in my connection. I guess I feel responsible for keeping the flame burning, the light shining—for everyone—so fearful of what might happen otherwise. So afraid to let go.

I promise to love you and your memory faithfully and forever. You were my shining star, my inspiration, and my greatest supporter. I will never forget what an extraordinary man you were in my life and how profoundly you touched those who came to know you. But I need to give myself back or, maybe for the first time, fully to the present, to my family, and to the moments that are happening right now. I fear that if I don't, my life will fall so far short of what it deserves to be and what you always wished for me.

Our beautiful son, Michael Grayson, named for you and embodying all that I adored in you—starts kindergarten tomorrow. He will soon be five. He is going to Kings Highway, just as I did when we lived on Sylvan Road. A strange and wonderful coincidence that simply has to be symbolic of starting anew. Oh, how I wish you could be there to watch him board the school bus for the first time. Oh, how I wish he could feel the strength and support you always gave me and that helped me and my self-esteem to flourish. I have to make sure that he and Emmy feel what I felt—as I know it was the most important foundation. It will come from me and Howie and the love of our family.

Time to go.

I am surrounded by beauty and love and peace.

I will miss you forever and love you for always. And if you need to find me, you will know where to look. I will be right here. In my life. With my extraordinary family. And hopefully, I will be smiling.

Forever, Stacy Pamela

food diary

My mom was not known for her culinary prowess. In fact, quite the opposite. She took a lot of flak for her cooking, though somewhat unfairly.

My brother and I were fed a proper meal each evening growing up, but unlike the meals we consumed at Granny's, they weren't particularly memorable. When Mom was first engaged to my dad, Granny generously shared some of her own special recipes with her, to offer her a head start on cooking for her new husband. It was also a not-so-subtle hint about what to make for her new in-laws when they came to visit. The story goes that each time Granny and Papa came for dinner, Mom made Granny's raisin meatloaf recipe, one of the many recipes Granny had given her. This tradition continued until many years later when my papa finally blurted out that he really didn't care for it at all.

Perhaps that experience scarred her because she never seemed to be interested in branching out beyond that. I ate a lot of raisin meatloaf as a kid, which, incidentally, I actually liked—especially the raisins that peeked through the top of the loaf and got crispy in the broiler. A disinterest in experimenting in the kitchen and trying new recipes is something I think I inherited directly from my mom, so I really *really* get it.

And yet, one day she either saw a recipe that seemed appealing to her or heard about it from a friend, and "Pineapple Chicken" was born, a new and forever family favorite. It's incredibly yummy and also tastes a lot better than it sounds (healthier and less caloric) if you don't allow yourself to pore over the ingredients. But that was of no concern to us as kids. There was literally nothing more exciting than learning that we were having Pineapple Chicken for dinner. Served over white rice with an extra heaping spoonful of sauce, which was intentionally a bit burnt. The dish was perfection. And really still is.

Years later for my Sweet Sixteen at a disco called Twin Faces East, another kind of chicken was served at the luncheon buffet. While it was tasty, there was apparently so much leftover that Mom took it home and continued to

serve it (the joke goes) for years (and years) to come. While she laughed about it with her taunters, you could also tell she didn't appreciate the joke one bit.

Mealtime for Mom was a bit more complicated. While she was always very fit (think aerobics, step, minitrampoline classes, and the like), she was also almost always trying out the latest fad diet. Most memorably, I recall one trendy regimen where she ate one type of fruit, and only that one fruit, each day for a couple of weeks. Pineapple one day. Only watermelon the next, and so on. I was always a bit envious when she got to eat one of my favorite fruits for dinner and I had to have an actual balanced meal.

Once a year, Mom went to the Golden Door, a very exclusive spa and weight management resort in Escondido, California, not far from San Diego. The Door was known for its Japanese gardens, spare decor, and of-the-moment healthiest fare. This was before the concept of wellness became a huge part of the cultural lexicon. She typically went during one of their women's only weeks. She looked forward to it and the expected weight loss, rejuvenation, and afterglow that came with the experience there, which was like nothing else.

Surprisingly, though, this sequence of dieting and then not, or the yo-yo diet as it has come to be called, never seemed to indicate any serious body-positivity issues or self-consciousness on her part. Mom was a positively beautiful woman. On some deep level, though very quietly, I believe she always knew that. Instead, all of this seemed to be more or less a maintenance program to allow her to indulge and never be forced to tame her famous sweet tooth. It was just a reasonable trade-off.

Strawberry cheesecake? Coffee ice cream? Carrot cake? She savored every bite. She used to tease that she would sometimes just prefer to have dessert and skip the rest. No doubt this is something else she's handed down.

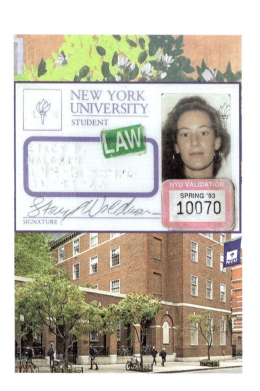

what's in a name?

My mom was endlessly encouraging. Until I tried to change my name.

During college, I had a serious boyfriend, Oren, who eventually became my fiancé and then, almost as quickly, my ex-fiancé. Let's just say that when we first started dating, I was extremely transfixed by him. He was next-level brilliant, extremely charismatic, and gorgeous, too. Oren sometimes encouraged me to do things I might not have considered otherwise.

In one of our late-night conversation marathons junior year, I revealed to Oren that I never really felt a strong attachment to my first name. Despite being named in memory of my mother's father, Sydney, Stacy was uninteresting, unalluring, and, well, just too common. I admitted that even when my name was called in class, it usually took me an extra beat to realize that Stacy meant me. Surely someone as creative and wonderfully individual as I fancied myself to be needed a name that reflected that. And so, Oren and I devised a plan.

We spent hours debating the merits of one name versus another. We discarded some of the names I had loved and was jealous of when I was a kid, like Sandy or Randy, Jamie or Jo. We obsessed over why, oh why, they didn't just name me Sydney. Surely, that was a way cooler, more worldly name—and after all, it was *for Sydney*. But Sydney wasn't in fashion at the time, and I guess my parents didn't want me to stand out, at least not too much, with a name that no one really knew.

In the end, I settled on a new name I really loved. It was different, but not too different. In my mind, it connoted nature and adventure, romance and mystery. It was feminine but rugged. Artsy, even. It was the new me. And then I called my parents to share this revelation with them, expecting some form of cheerful encouragement and appropriate enthusiasm. Instead, I got "What? Which name? Why on earth would you change your first name?" and on and on. In truth, it only really took one rejection for me to relent. The last thing I

172 lightkeeper

ever wanted to do was upset my parents. It wasn't worth it. I'd just let it drop. And I mostly did.

Until a couple of years later, several months before I was to begin law school at NYU, when my dearest friend, Louisa, gave me an idea. She suggested that starting law school was the perfect time to change my name. I didn't have to do it legally or permanently, as I'd originally planned. I could simply introduce myself to this completely new community of people with my new name. How was that any different than someone named Elizabeth, for example, saying her name was Liz or Lizzie or Bethy? Thinking of my new name as a nickname would allow me to inhabit this new persona *and* it wouldn't upset my parents. It was an inspired compromise. I thought it just might work!

And so, all summer, as Louisa traveled abroad in France, she sent me postcards addressed to my new moniker care of Stacy. When each postcard arrived, I smiled, becoming giddier and more sure. I was excited to finally have a name that I identified with and that I *chose*. What a gift. I practiced saying it aloud in the mirror. I role-played an introduction so I could get used to it and then, I waited to take it for a spin. I was ready to become *Sierra*.

When the first day of law school arrived, I marched into Vanderbilt Hall, the impressive brick building on Washington Square South, with a huge amount of self-confidence. All the incoming students were meant to meet in the lounge on the main floor before orientation groups were assigned. As I walked in, I took a deep breath—not just because I was embarking on a new, reputedly challenging pursuit and lucky to have been given this opportunity, but also because I knew that the next few minutes were going to be critical for the launch of my new name.

I quickly decided to look for a woman to talk to and change things up from my normal go-to of seeking out men. I introduced myself to a pretty blond woman with a warm smile and asked if I could join her. She motioned "of course" and then, in a flash, I realized I knew her. I *already knew her*. I couldn't believe it. Details flooded my brain, and I even recalled her name. It was Nicole, who was one or two years younger than me and had been in a neighboring bunk in my group at Camp Birchmont.

Out of all the complete strangers in this room, I somehow picked someone

what's in a name? 173

I knew. My plan was foiled. Or was it? I reminded myself that it was only a nickname and it had been almost ten years since I last saw Nicole. Maybe all was not lost. As I sat down, she said, "You look so familiar."

"Yes, hi! You're Nicole, right? We went to Birchmont together!" I replied, trying to be casual while still plotting how to pull this off.

"Oh, of course, but I am so embarrassed. I don't remember your name."

After a longer-than-felt natural pause, my heart racing, I meekly offered, "It's Stacy . . . Stacy Waldman." Not as good of an overture as Bond, but I was buying myself time.

"Yes, Stacy! Wow, it's been so long!"

And then it happened.

"Yeah, maybe about ten years? But you know, it's so funny. No one has called me Stacy in so long," I proffered.

"Oh really? What do they call you?"

I gulped. "They call me Sierra."

The name hung in the room for what seemed like forever, trying to get some air of its own so it could survive. And then she laughed. Oddly . . . laughed! And exclaimed, "That's so stupid!" Perhaps there was something about the way I'd said Sierra that suggested it was a name I didn't wholly approve of? Hard to know for sure.

Within seconds, another first-year law student joined our little group, and Nicole introduced herself and her new/old friend Stacy. And that was the end of Sierra at NYU School of Law.

I didn't appreciate then what I know now to be true: that in the Jewish tradition, your given name is more than a name. It's mostly about the giving. Even if I thought choosing a new name that started with an "S" was the same as being named Stacy in honor of my grandfather Sydney, it was not at all the point. The tradition is about the act of honoring an elder. It's a symbolic transfer of long-revered, celebrated, or admired traits of the person who has passed from this life and the person who will grow into it. It's another form of lightkeeping, if you will, and it is far more meaningful than I surely realized then.

Years later, the opportunity—actually, the gift—of being able to name our

children for those treasured souls we had lost was something I took so seriously. I recognized (with far more maturity than I had at twenty-two) that these names would be a daily reminder to them—and to us—of the legacy they carried with them.

By the time our son Michael was born in 1998, my papa, Eddie, had passed. He died just a short while before Michael arrived, and so, his name was added to my dad's, Darcy's, and Glenn's as loved ones we wanted to honor. Michael's full English name is Michael Grayson, named for my dad and Glenn. His Hebrew name, Elad Doron, is for Enoch and Darcy. When Emily came two years later, there was no question that we wanted to honor the same four people. Emily's English name is Emily Daryn, and her Hebrew name is Gilannah Michal, which forever connects her to the light of each of these beloved people. Importantly, Howie and I believed this would also irrevocably and powerfully bind Michael and Emily together. It is a link they share daily and for a lifetime with four extraordinary humans.

Howie likes to tease that I really like naming things, and he is right. Whether it grew from my distaste for my own name or something less profound, it's something I actually love. I now think it's connected, too, to the idea and importance of lightkeeping. Knowing that there is a new life, full of possibility and promise, and that the thoughtful and deliberate act of choosing a name carries with it such significance is truly a blessing.

Fast forward to today. During the pregnancies of our daughter Lissy and our daughter-in-law Kylie, the subject of what to name their babies was an irresistible one. Both couples have done such a thoughtful job of choosing names for each of their two children that honor and pay tribute to grandparents or family members who are no longer with us. And in the naming ceremonies, they beautifully shared the meaning behind each name with all in attendance. It has been among the most moving moments in my life to learn that my mom—and her unique Jessica characteristics—was among those so honored. I hope and know I will see her through my grandchildren in the years to come.

(un)happy new year

Certain things you never forget. We all remember where we were or what we were doing when that call came in. The one that changed our lives or set us off on a new and strange path. I'd already experienced one critically life-changing moment, so I may have believed that it counted for more than my share in this lifetime.

This time, bad news came just after the New Year 2018 and only a few minutes after we arrived home from a long and lovely family vacation in the Turks and Caicos Islands. I was standing in our kitchen in Westport processing a heap of accumulated mail—which I generally love to do—when Mom called. Her calling us wasn't odd in and of itself. But I had just texted her when we landed at JFK airport, so the fact that she was reaching out so soon felt off. She knew that I'd be running around, unpacking, starting laundry, and so on.

I can no longer reconstruct the exact words she used, but the sensation I felt in response to them was instantaneous and unforgettable. Her words and their volume morphed, distorted as if suspended in Jell-O, jiggling, part translucent, part opaque. My heart raced. My pulse quickened. And then a huge wave of nausea pummeled me and almost took me to the floor. Just like in the movies. But this time, it was real.

The mention of cancer always comes with a heaviness. We all know someone—likely more than several someones—who has suffered through it. Thankfully, some make their way through to the other side. But Mom had pancreatic cancer, which has its own unique force and reputation. It immediately infused me with an amorphous, overwhelming fear. Time stood still while I tried to comprehend what she was saying. How much time was left? How would we move forward? In the same instant, I was aware that my inner panic needed to stay inside, that I had to respond to her news with a measured and supportive confidence. I knew I had to snap into action, put aside my fears, and focus with laser precision on advocating for my mother in the weeks and months ahead.

The days that followed were intense. We all needed to get educated—and quickly—about what Mom was up against and how best to proceed. Not surprisingly, she was mostly calm. Since Carl's first wife had succumbed to the same disease years before, it was clear that Mom was far more concerned about Carl and his emotional state than she was about her own. The thought of putting him through an already excruciating ordeal a second time seemed next-level unfair. And truly, it was. Carl was stoic. Determined. Resigned to support my mom in every way possible even though he was more aware than most of us that the odds were not in her favor.

And yet, we followed the protocols to a tee. With complete cognizance of and gratitude for the contacts we had in our network, we relentlessly pulled every string we could to get her in to see the best doctors with the most expertise at the best hospitals. Knowing that the passage of time was not our friend, we drove all over the tristate area getting second and third opinions, interviewing surgeons, and assessing the most favorable course of action.

It quickly became clear that her best chance of surviving this diagnosis was to have the pancreatic tumors removed in a procedure called a pancreaticoduodenectomy, better known as the Whipple procedure after Allen Whipple, a surgeon from Columbia University who devised the procedure in the mid-1930s. However, we also learned that this procedure, while highly effective, had its own risks. Plus, it was only appropriate as long as the cancer resided solely in the pancreas and had not yet metastasized. Lots of scans followed, and it appeared to be more than just possible that the cancer had already begun to spread.

Confirming this suspicion, however, required a complicated biopsy in a location that would be difficult to reach. More doctors. More consultations. One team at Yale New Haven Hospital said the biopsy location could only be accessed by a huge and terrifying-sounding surgery that required them to open up her chest. Thankfully, another team of specialists, this time at Mount Sinai Hospital in New York City, said they did this type of procedure often, far less invasively, and quite successfully. Thankfully, Mom was a viable candidate.

In the end, she was given the best care and recovered from the procedure quite well, but the pathology reports were conclusive. The pancreatic cancer

was in her spine, and thus, the Whipple surgery was no longer an option. She would have to endure multiple rounds of chemotherapy, followed by radiation, in order to try to reduce the tumors. While we tried to remain optimistic that she could beat the odds, there were no guarantees. And the chances had just diminished significantly.

Shuttling around Connecticut and New York, in and out of countless offices and waiting rooms, was exhausting. It took all my energy not to let the scent of my fear escape into the air around us. Mom remained mostly unflappable throughout, like the A-student, teacher's pet that she was, dutifully going from place to place, gathering data, and following protocols. There was more than one occasion when I had to tell myself that I simply couldn't go off the rails—emotionally—and surely not if Mom was managing to keep it all together. It was an astonishing lesson for me to watch her handle this massive undertaking with such grace and poise when she had every justification in the world to *scream* at the top of her lungs.

To and from each appointment, the tone in the car was mainly a quiet one. There were a lot of long silences among Carl, me, David, Yvette, Howie—and Mom—as we wrestled with our thoughts and her fate. Hoping to lighten the mood, we surprised her once with a fresh loaf of her favorite raisin-pecan bread from Eli's on the Upper East Side, already sliced for easy sharing. It really made her smile—a sweet, knowing smile that melted my heart.

On January 31, 2018, just about a month of appointments later, with many courses of chemotherapy now prescribed and upcoming, I hit a wall. As each new test or procedure introduced new obstacles and staggering complexities, I could feel overwhelming anxiety, sadness, anger, and depression taking hold.

The feeling of being unable to do anything meaningful or make a difference was agonizing and numbing. As I lay awake in tears one night, I tried to formulate an idea. I needed to figure out some positive affirmation that I could do or offer every day—to will her to the other side of this terrifying disease, to inspire her to beat the odds and crush the statistics, to help her survive and thrive. I decided that each day I could share a picture of my mom on Facebook to breathe new life into moments past, to celebrate how much she was loved, and to build strength and forge a community of support for her.

The next morning, I called Mom to share the idea and ask for her consent and participation. This was critically important, as I would be talking about her diagnosis publicly—with all that it implies—in this digital world. After some consultation with Carl and getting his buy-in, she called me back to say, "Sure, go ahead." Undoubtedly, she did not fully understand what it would grow to be. Nor did I.

i love you, mom

On February 1, 2018, I posted this image with the caption "I love you, Mom" followed by a red heart emoji. It shows Mom sitting pensively on horseback, glorious in her effortless natural beauty, on a family weekend away in Vermont. It was late October, and there was a lovely fall chill in the air. Judging from the look of David in the foreground, he must have been around ten or eleven. Mom was about thirty-four. There wasn't any magic to this being the first image. There was no real mission or message behind it. I just had to start. The image captures so much about her within its borders.

I explained to my friends, followers, and community then that many of the photos I planned to share weren't taken by me (and sometimes the photographer was unknown). Yet since photography is my meditation, my prayer, my gift, and my offering, maybe sharing these images *was* what I could do. While medicine does what it can.

Of course, we all know too well that Facebook and other social media sites have many flaws, but one of their unequivocal strengths is connectedness. I wasn't sharing these daily musings to elicit comments or artificial empathy, but instead with the hopes that whatever good, whatever power, whatever positivity it put out into the universe might find its way back to my mom, and exponentially so. And that she would feel how loved she was. Both Mom and I were completely surprised by and unprepared for the volume, intensity, and generosity of the interest in her diagnosis and the battle ahead. From the very beginning, people were engaged: asking questions, offering encouragement. It quickly became a daily elixir that buoyed us all.

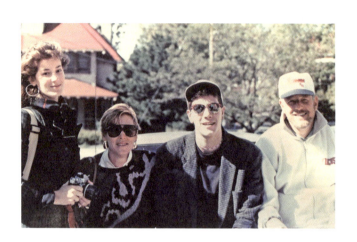

which would you rather?

One learns so much about life and love, devotion and compassion, and relationships from the suffering caused by an accidental loss as cataclysmic as the one I've had to endure. Priorities. What matters most—in life and in death.

When my kids were in elementary school, we had a card game that came in a small, bright-blue metal box. Inside the box were at least a hundred cards posing some suggested dinner game questions: Which would you rather be? A snake or a crocodile? A cloud or the rain? A car or a train? The game, of course, was meant to challenge the kids to think about the characteristics associated with the two things being offered, to reason through their selection, and to be able to articulate the "why" behind their choice. It typically inspired a very amusing conversation, and it was always fun to witness their minds in motion.

Similarly, though far more profoundly, I've often considered, "Which is worse, an immediate and accidental death or dying after an extended illness?" Of course, the answer depends on whether you are the one doing the hypothetical dying or one of the many left behind. I wish that thinking this through was a purely speculative or intellectual exercise, but alas, for me and our family, it wasn't. And yet, because of the unique circumstances I found myself in, I sought to find the answer, to learn the lessons that one experience could teach me and allow it to guide me through the other.

I didn't get to say goodbye to my dad. Or to say anything, really. I didn't get to say "I love you" one last time. Or "thank you." Or to express how grateful I was for every minute of every day that I got to be his daughter. I didn't plan for his absence—ever—and certainly didn't expect it to come that soon or in that way. In fact, like many of us do, I counted on and took for granted that there would be a bright and beautiful tomorrow and many more after that. I hadn't yet fully registered that tomorrow isn't promised. I hadn't taken the time to record his stories in his own words. I hadn't the foresight to keep (as treasure) the sound of his voice on my answering machine or the message it conveyed.

There are no videos of how he moved or how he laughed or that show him *alive*—quietly breathing, living his life in three dimensions.

I knew I couldn't let the same thing happen with Mom—and because I had the absolutely awful forewarning of her death in the form of a diagnosis of one of the deadliest, notoriously unsurvivable cancers—I knew this time around, this loss could be different. And that it had to be.

Grief is not a straight line. It's not something you can dutifully progress through, checking boxes and steadily improving. It is complex and confounding. In many ways, it never truly ends. Memories and milestones propel it to ebb and flow. Some days it sits heavy and horrible, and on others, it can be wise and wispy, quietly hovering just overhead. My journey alongside grief has mutated in more ways than I can keep track of. My gift to myself is that I allow it to be whatever it is or needs to be on any given day. I don't judge it or impatiently urge it to change. I let myself feel it and the singular love with which it is infused.

Ultimately, the living tribute I created for my mom was instrumental in preparing me to process and make peace with the inevitable grief I would feel when she passed. It allowed me to work through the range of emotions I was experiencing and to be able to do some of that hard work alongside my mom, while she was here with me—only a phone call or a FaceTime or a short drive away. And yet even now, six years after her death, there are days when I feel like I am starting all over again. Yes, *still*.

The grief I felt and still feel from the accident—in some ways, it's as raw as ever—has additional layers to it. I hold it differently in my body, along with a complicated web of scar tissue from the shock and the continuing aftershocks it set in motion: relationships transformed or even decimated; futures shifted both subtly and dramatically; a stunning butterfly effect, changing all moments to follow. That grief had two prongs: a seemingly insurmountable, deadening sadness and also an almost incongruously odd opening or expanding. It was as if the out-of-the-blue-ness of the accident created a safe space within which I could change—perhaps only temporarily. It appeared as if the world would give me the benefit of the doubt, even a get-out-of-jail-free card—a momentary chasm or silencing in the universe where all rules and norms

were suspended and I could more clearly recognize what I really needed and wanted. Though people couldn't really understand what I was going through, they seemed to understand the depth of the trauma. In exchange, they offered quite incredible kindness and compassion. Permission to set out in a new direction. The seeds of how to eventually live fully again.

Lately, I am trying very hard to focus more on the extraordinary good fortune of having my mom and dad as parents and all that has meant in my life and less on the immeasurable depth of losing them. However, I believe the constancy of missing them is nevertheless integral and important. In their absence, we are inspired and compelled to remember. My gosh, those memories are ever sweet.

broadway baby

My mom wasn't the bold or boisterous type, at least not on the surface. She exuded a quiet calm and a certain warmth and softness that prompted many friends to comment over the years, "Your mom is so sweet." She was, indeed, so very sweet. But she was also incredibly passionate. When she loved something—really loved something—the energy and enthusiasm that burst out of her was second to none. At the top of the list of things she loved were camp, specifically Pierce Camp Birchmont, and the theater, especially Broadway. Though pretty much any type of live theater lit her from within. That spark pulsed and glowed in her with an unmistakable radiance.

She had an encyclopedic knowledge of Broadway shows and song lyrics. She even put that skill to great use as a long-standing volunteer at the Goodspeed Opera House and Norma Terrace Theatre in Ivoryton, Connecticut, where she was charged with cataloging playbills for the Broadway library. And thanks to several charity auctions, she also appeared on stage as a chorus member or extra in several musical productions over the years. Each performance was an experience she absolutely cherished.

Perhaps by osmosis, I developed a similarly deep love of both camp and theater. I don't think my mom wanted to be in a world where she couldn't share these passions with her kids, so she did what any parent would do . . . she worked at it. One spring break when I was in middle school, my mom planned a three- or four-day theater immersion experience for the family in the guise of a vacation. We decamped to a nondescript New York City hotel and had tickets for one or two shows, mainly musicals, each day.

The itinerary was lost long ago, but the experience that sticks out in my memory most was seeing Lucie Arnaz in *They're Playing Our Song*. I had an incredibly bad sore throat that day. While I was miserable and realistically should have stayed back at the hotel, I not only went to the theater, but I also loved every minute of it. I loved the chance to share an experience with my mom that she clearly adored. It made me feel connected to her in a way that

really mattered. I became an insider and member of her special club. I can almost taste the slightly chewy Pine Bros. cough drops (I was equally enamored of the wild cherry and honey flavors) and can easily re-create the feeling of the likely strep-induced crackle of pain in the back of my throat.

Most importantly, I was hyperconscious of this moment. Going to the theater transformed from something you could do to something I had to do. I, too, was hooked.

In the years that followed, I shared countless theater experiences with my mom. Sometimes we went in a small group with a close friend and her mom or as part of a birthday celebration with my brother and Yvette and their kids or with my family. But very often, it was just the two of us. The energy I could feel sitting next to her in the theater was so powerful, truly electric. No matter the show, you could always sense that being in a theater audience was her happy place. She knew every word to every song in practically every show. The joy she exuded looking up at that stage was an extraordinary thing to behold. Her expression, her reactions, her emotions, her tears are forever seared in my mind. I was always, literally always, grateful to have been able to experience it together.

During a break in her chemotherapy treatment in April 2018, with her now hairless head adorned with one of the many printed silk scarves she had acquired, we went back to the theater. While the treatments were noticeably taking their toll on her, she was strong enough to make the trip into New York City. We were both appreciative of the opportunity to suspend reality for a couple of riveting (although not especially uplifting) hours seeing Edward Albee's *Three Tall Women* on Broadway. This time surely felt different than all our previous outings. It was highly charged. Though we were still hopeful about her prognosis at that juncture, it definitely occurred to each of us that it could very well be the last time we ever saw a show together. It didn't need to be said aloud. But we both knew. So much was racing through our minds in the dark and quiet theater.

But mostly, I was just happy to be holding her hand.

i love you, mom—july 20, 2018

In the very dark days of winter, I honestly didn't know we could and would be here; that Mom could and would be here. It felt like an interminable labyrinth of bad options. And so . . .

Today is a BIG milestone in this (crappy) journey—it marks the last day of chemotherapy and the completion of a huge and pivotal step leading toward the goal of total remission.

Mom, today's image may be a surprising one—a little sexy? A bit revealing? A tone-deaf choice during the critically important #metoo social movement? But it's one I chose with (probably too) much thought.

The pictures I have shared for the past 169 days have created an incredibly interesting mosaic of your life. No matter the time, the style, the context, they show you to be a woman of rare outer beauty and unusual inner beauty, too. You have shown a pensiveness, a quiet resolve, unending kindness and compassion, as well as an individuality, a buoyant love of life, a deep and true joie de vivre. This image informs that story, too. But it also says more. It shows that beneath that spectacularly gorgeous body there is a FIERCE, IMPOSSIBLY STRONG, PROTECTIVE, POWERFUL, TAKE NO PRISONERS, KICKASS WOMAN. I can almost hear the ROAR. And that's just the woman I wanted to see today. You have not only persevered through these grueling treatments, you have risen above them with grace and calm. You have continued to live your life with purpose, focus, vision, and optimism. I know we are short of a victory lap and there are still real challenges ahead but . . . it feels close. Attainable. Within reach. F-U CANCER. Mom, I couldn't love you more.

the sweetest sound

In the days, months, and . . . really, years after the accident, when the tunnel of grief seemed to be closing in on me, growing darker by the minute, one solace, at least sometimes, was uncovering a lost artifact of connection to my dad. I would go through my archives of printed photographs and acrylic boxes lined with slides and search again for something new. Hoping to discover another unrevealed portal into my memory.

At one point, I became obsessed with locating video footage of my dad. It seemed like a way to confirm the sound of his voice, which was always running in the background of my mind. I thought surely some of his friends might have captured a few seconds at a party or occasion long since forgotten. Since he'd died in 1995, before everyone had a smartphone with impressive camera capabilities in their pocket, my quest came up short. The bottomless emptiness I felt knowing that I would not, could not ever hear his voice aloud again made me so sad. I'd try to reconstruct the last message, or any message, he'd left on my home answering machine. Those machines were solely analog and ran actual mini cassette tapes that you would routinely erase after listening to the day's audio missives. That was long before the cloud had a secondary, ubiquitous meaning.

In the last months of Mom's life, when it became less and less possible to ignore the inevitability of her death from this insidious disease, I found myself ever aware of the incremental, pulsing beats of the clock. The ticking continued steadfast and unabated to the exact moment when it would abruptly stop. I wanted so badly to prepare myself in a way I could never have done with my dad. I thought I should record Mom telling stories or just talking . . . about anything at all, to fix her voice permanently in a place that would allow me to recover it whenever I needed it and always.

The challenge became how to actually do that without signaling that I had in some way already given up hope. Of course, I knew that she knew what was what. We all knew. But acknowledging an end—no matter how near or

far—seemed to beckon an irreversible omen. That felt especially unbearable. I was loath to even give the thought any air, as if purely refusing to consider it would make it less so.

In mid-October 2018, Mom was admitted to Middlesex Hospital for an initially unidentified complication related to her treatment. It was eventually diagnosed as sepsis. Howie, David, and I drove to the hospital. Fear-induced adrenaline coursed through my body, distorting and muting all other ambient noise. Dark and dire thoughts bounced off my skull as if they were trapped in a padded cell, unable to escape.

Despite the mounting uncertainty about what was going on and the need to be admitted for observation far longer than hoped, Mom was mostly herself. Calm. Measured. Mostly upbeat. On one of my visits, as she recounted a story, there was a natural pause in the conversation, and I asked if I might record her with my phone. Once she recognized that I meant only an audio recording, she relaxed into the idea and acquiesced. But I could see from the look in her eyes that she understood my motivation. She knew. We all knew. I started to record a series of questions and prompts, followed by her answers.

That day in the hospital, she talked about when her family got their first television, a hand-me-down from her mother's twin sister, Maude, whose family was "more well off." She giggled through a ridiculous story about my dad accidentally getting two sets of shots in his head to reverse his increasing baldness when the doctor didn't realize his colleague had already administered the treatment. Even with a double dose, it proved to be wholly ineffective. She mused about summers at Shapanack in the Catskills where she had a crush on a boy named Peter, rode horses, and swam with her mother in the cold, clean lake. And she shared more about her mother's time as a mezzo-soprano chorus girl with the Amato Opera on Bleecker Street. She mentioned that WQXR, the classical music station, was almost always playing in the apartment when her mother was home. But when she wasn't, Mom would always switch the channel to WMGM, the pop/rock station.

One such day when Mom was a senior in high school, the station was running a contest. It's a great story, so I'll let her tell it:

OK, so it's senior year in high school, and one of the radio stations I listened to was WMGM, and they had a contest: win a date with Bobby Darin. So I said, OK, fine, I'll give it a try!

Darin was a big star already. He had "Mack the Knife." Oh, actually, I'm not sure he had "Mack the Knife" then, but he certainly had "Dream Lover" and "Splish Splash," which were number-one hits. It wasn't so much that I was a huge fan, but I just thought it might be fun. So I had to write in sixty words or less why you want a date with Bobby. And so I wrote this poem:

> *A date with Darin would be neat.*
> *He's so darling, daring, sweet.*
> *His voice, it swings,*
> *He's King of Kings,*
> *His disks all rock that crazy beat.*
> *In my book, he is on top.*
> *I wish I was his "Queen of the Hop."*
> *If I went "Beyond the Sea,"*
> *He'd still be the greatest guy to me.*

So anyway, I get this phone call. Yeah, yeah. Jessica, you won, you won the contest! I don't think anyone else wrote a poem, which is probably why I won. Well, you don't know what other people did, and um, maybe I was the only one who entered. Who knows? Probably not!

So on the night of whatever this date was, a limousine came to pick up me and my mother at our apartment in Rego Park. I needed a chaperone because I was only sixteen at the time! The disc jockey for the show, whose name I think was Mike Lawrence, was there as well. And they drove us into the city to the Copa Cabana.

We watched the show. I think we watched the show first. I'm not sure when it was we went backstage. And at the time, I'm not sure if this was pre-Sandra Dee or after Sandra Dee, but he was dating an actress called Joanne something or other, or maybe she was a singer? And I think she was back there, too. So it wasn't really a date, but I got to meet him, and we got to take pictures together.

And another good thing that came out of it was that our senior prom was maybe a month later, and none of the guys in the group that we were in had

done anything about planning for after the prom. So I asked the radio station if it would be possible for them to make a reservation for X number of people to come to the Copa.

And they did! And we got to see Paul Anka that night, too.

In the days and weeks that followed our Middlesex Hospital story session, I continued to record Mom sharing snippets from her life. On Thanksgiving, when she wasn't well enough to travel to Westport for the holiday, we relocated the family gathering to her place in Deep River, Connecticut. Carl; David and Yvette and their kids, Rachel, Jacob, and Ava; and Howie and I, along with Michael and Emily, all sat around the dining table for hours while Mom regaled us with animated anecdotes about everything, from a complete annotated glossary of her camp boyfriends by year to how she ended up on a blind date with Art Garfunkel. She also told us how she first met Dad when she randomly asked him for a ride home from a required sorority pledge event, how their summer boat trips with friends evolved, and even how she and Dad and the Selverstones had run aground once aboard *Tortoise* in the Shinnecock canal and spent a long, exhausting night

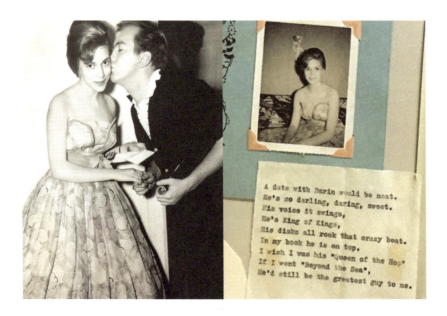

waiting for the tide to rise. She boasted of her ability to say the Greek alphabet forward *and* backward, a remnant from her Iota sorority days at Queens College, and then demonstrated it for us. David, the kids, and I sang along with her to numerous Birchmont songs, which we all still (and will always) remember like it was only yesterday.

Mom had a truly outstanding memory for the details and an amazing ability to recall facts on and features of anything we could think to ask about. She also remembered the first and last names of just about everyone she ever encountered. And even the correct spellings.

Her voice that Thanksgiving Day was so crisp and clear. Relistening to the recordings now, there is no detectable sign of the disease lurking inside her body. Her tone was bright and elevated and, dare I say, even joyful. We were all overcome with gratitude to have shared that time together.

Of course, I was very aware as we recorded these moments that I would one day, not long after, be able to go back and relive these stories through her words. In her voice. These digital remains would one day replace our cherished conversations. A poor substitute and a very tall order, indeed. And yet, whenever I need to hear her voice, I have these stories in my pocket. In the cloud. Always.

bright lights, big city

In 2017, as I tried to get my head around Emily going off to college, Howie and I decided we would rent an apartment in New York City, believing that ready access to everything the city offered could be the perfect distraction from our soon-to-be-empty nest. We had always planned to have Mom and Carl join us in New York City for an overnight or a weekend getaway, but given the twists and turns of her illness and the treatment protocol, those plans got dashed time and again.

Finally, Mom either sensed a window of opportunity or that time was running short, and she committed to coming in for the night. It marked a return to the city she loved so much and to see where we had been spending many of our days and nights. I think it really helped and comforted her to be able to visualize where we were.

She wasn't feeling especially strong that crisp and cold December day, but she felt well enough to take a short walk to Union Square Park, just a few blocks away. We bundled up in hats and gloves and walked slowly around the perimeter. A journey that would have previously been effortless instead seemed to take all of her might. With the city spires towering overhead, she seemed even smaller and more diminished than I was prepared to accept, but her determination, buoyancy, and enthusiasm for the outing were a welcome diversion.

When we came in from the cold, she settled in the corner of the couch to regain her strength, in the exact place where I typically lie, and eventually opened up Words with Friends on her phone—no doubt to handily finish off the day's opponents.

I took this photo just then.

Thanks in part to this image, it doesn't take much for me to imagine her precisely there or to conjure up her sweet smell; to feel the softness of her sweater, the warmth of her hands; and to see the kindness in her eyes. Just outside the

frame, I can still hear her voice. Its tone and spirit untouched. It often feels as if I could reconstitute every particle and cell in her being; that she could simply, seamlessly appear. When the tears roll down my cheeks, faster and faster, I work hard to feel grateful for the strength of that connection and to not be incapacitated by the force of missing her. It's a delicate balance, indeed.

long goodbye

In the last months before Mom died, there were many days where I convinced myself she would beat all the odds and survive, that she was miraculously and completely healed, and that the testing and the science would soon catch up to prove exactly that. On those days, where she seemed so much like her healthy self—vibrant, engaged, and very much alive—I quite shortsightedly constructed a space where this was true. This only allowed reality to crush me with additional force.

Very slowly, and then very quickly, I had no choice but to face the irrevocable truth that she was going to die and soon.

In early January 2019, Howie and I took Michael and Emily for a short trip to Miami Beach. Emily was a freshman in college then, and Michael was about to leave for his junior semester abroad in Prague. The months just before were overwhelming, scary, and exhausting. I think we believed then that some semblance of normalcy, plus a dose of warm air, would be good for them and also for us. And so, at Mom's insistence, despite things feeling undeniably tenuous vis-à-vis her health, we still went.

Other than the relief of being outdoors and in the sunshine in winter and some lovely meals and time together with the kids—it wasn't much of a vacation. I was in a constant state of high alert every minute of every day. Minutes after we landed and were still on the runway, I received a call from my brother telling me that Mom appeared to have had a small stroke the night before. Then there were the daily check-ins that belied a new phase in her illness and the quickly accelerating velocity of reaching the end.

My mind was reeling with what-ifs. My physical body was in Miami Beach, but every ounce of my being was in Deep River with Mom. Every synapse of my brain was trying to make sense of and preprocess what was about to happen. Billboards in my mind and everywhere I looked were screaming at me in all CAPS. My mother was about to die.

We only stayed in Florida for a couple of days and went directly to Mom's

house upon returning to Connecticut. I can conjure up every instant of those next few harrowing days. I was in a state of numbness—constantly trying to make sense of the intense sadness that was always hovering nearby, enveloping my body in a dense, thick foam. At times, I was conscious of just how different this loss was from losing Dad and grateful for the time we had to process much of it together. It was an extended goodbye that was no less painful a loss, but in fact, the circumstances allowed for a richer, layered, and ultimately grounding (de)parting.

Mom was less and less herself in those last few days—and while that was extremely disconcerting, it forced us all to focus much more on her pain management and physical caretaking and less and less on the emotional upheaval of her impending absence. It was impossible not to feel gutted to see Carl going through this again. We all tried to be as supportive as possible to one another, knowing all that we knew about each of our personal experiences and how we were and were not prepared for the inevitable.

The hospice nurses were extraordinary—as warm and loving as you always hear that they are—and were able to give us guidance in these uncharted waters. They helped us understand what her body needed and what was happening, invisibly, inside. At one point, one of the nurses needed some assistance inserting a catheter, and I had to help. That moment was a gateway to a previously unknown place where, through my hands, I was inside my mother's body in a way that I was never meant to be. It was unimaginably upsetting on its face and more so that Mom seemed then to be completely unaware of what was happening. Though it was a loving act for her comfort only, it still felt like a violation of sorts—and a wholly unwelcome and unnatural reordering of the parent-child relationship. I just cried and cried.

Only a day or so later, the end neared. We sat around her bedside—now relocated to the main floor in the family room of the Deep River house—and held her hands. We sang to her. We talked to her. We played music we knew she loved. We hugged her. We cried for her and for us. We cried for Carl. We cried for the magic and the memory of our extraordinary childhood and how fortunate we were—truly blessed—to have had her as our mother. It was a remarkable feeling to know that nothing had been left unsaid between us.

Nothing was unresolved. She knew how I felt about her, how we all felt. And we all knew how she felt about us. That opportunity felt like the greatest gift.

As the night wore on, we decided it was prudent to try to sleep for a bit and save our strength for what was likely around the corner the next day. We agreed to take turns checking in on her. But only minutes after we walked away to gather pillows and blankets and find a place to rest—when she was finally, and as she wanted to be, momentarily alone—she took her last sweet breath.

The silence was deafening. And she was gone.

It was January 12, 2019. The world shifted on its axis yet again.

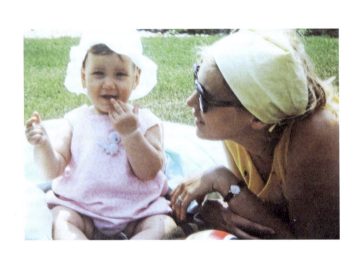

a living tribute

When I began the "I Love You, Mom" project, my hopes for it were somewhat modest but important. By sharing images from my mother's life on Facebook—tiny slices of her then-almost seventy-four years as a daughter, a summer camper, a counselor, a student, a wife, a mother, a grandmother, a friend, a teacher, a philanthropist, a passionate theatergoer, and a lover of language (to name just a few of the hats she wore)—I had hoped to create a living and breathing portrait. One that would both delight and remind my mom of the wonderful life she had lived and the range of people she had impacted and influenced.

I also had hoped that in sharing these images each day from February 1, 2018—which was one month after her diagnosis of metastatic pancreatic cancer—until January 13, 2019, the day following her woefully untimely death, that I could somehow create and fuel a community of supporters to nurture those memories and to engage my mom in an online conversation that would buoy her spirits and occupy her time in a positive way. I set out to harness the immediacy, range, and force of social media for good. And it worked.

There were moments along the way when I began to believe the swelling force of the movement that formed around her over that one year could somehow change the course of her prognosis or, at the very least, extend her time. I think she believed that, too. The love and positivity that flooded in her direction, from near and far, from likes and loves to comments and questions, was so empowering and transformative that maybe, just maybe, it could work. The digital conversation quickly spilled offline, too. My mom was supported in so many unimaginable ways by many she knew and loved and by many more with whom she had no personal connection.

When I started the project, my mom asked how long I thought I might do it for. In those first terrifying days, I honestly thought I would do it for as

long as she was alive because I feared the accelerated pace of the cancer. But wanting to be optimistic, I instead said to her, "For a year. Let's start with that." In that one instant, a goal was born. Let's make it to a year. One year. Please, at least one year.

Every day, Mom woke up looking for her post. She was curious and excited to see what image I would choose and what I might write about it. She eagerly anticipated interest and engagement from the community and responded enthusiastically to questions and comments. Sometimes she called me to gratefully acknowledge a particular post or to clarify my query about a date or time, but true to form, she never hesitated to point out an errant typo or mischaracterization, which of course, I quickly remedied.

I spent a fair amount of time daydreaming that when she reached the one-year mark, I would make a book of accumulated posts. It would be a gift for her, a small but content-rich, beautiful treasure to have and to hold. Together, we could celebrate the victory of both the medicine and memories and marvel at the astonishing community that we'd built.

Her story, like far too many stories of cancer, did not have a happy ending. Although most days this plain fact is still unbearable and heartbreakingly sad, I nonetheless found myself wanting and needing to make that book. I needed to find a way to redirect the gift that was intended for my mom to others who were still fighting and who might still prevail.

In honor and in memory of my mom, I ultimately published that book as a seven-inch-by-seven-inch little treasure and made its distribution into a critical mission. The book became a way to help fund groundbreaking, life-changing research to defeat cancer, and in particular, the pancreatic cancer that took her from us. In partnership with the Lustgarten Foundation, the leading-edge pancreatic cancer research group, donors to the "I Love You, Mom" initiative received an ebook version of *I Love You, Mom* as an acknowledgment of their contribution to this worthy cause and in gratitude of their kindness and support of my project and my mom.

My hope was that readers would not only learn about my mother, my journey, and my loss but that they would also, like so many who followed along

with the Facebook project day by day, be similarly inspired. To be grateful for the relationships in their lives—with their own mothers, daughters, sisters, or friends. To mindfully nurture and attend to those relationships and to cherish the simplicity and beauty of the everyday.

Every day that you can.

center stage

The days immediately after Mom's death were distinctly different than the days following the accident. We knew this was coming. And while we were all far from processing the enormity of the loss, we were still somehow grounded in our bodies and not reeling, untethered and flailing from shock.

Michael was due to leave for his junior semester abroad in Prague, and while Mom would surely have applauded any logistics that allowed him to keep his plans, we couldn't quite make that happen and had to delay his departure so that we could all be together. A decision was made to hold a memorial service at the Westport Country Playhouse, an iconic and much-revered regional theater in town. It was a place that Mom loved and had generously supported over the years. It was also a meaningful reference to her lifetime dedication and passion for live theater.

We busied ourselves with crafting just the right eulogies, sharing details of the planned service, and working out the particulars of the shiva that would follow, as well as a list of places mourners could make a charitable contribution in her honor. Minutiae, really. But all necessary. Michael worked on a video tribute that incorporated images of Mom as well as the sound of her voice. A friend who is also a beautiful and accomplished singer agreed to perform a few songs, Broadway favorites Mom adored that were spectacularly poignant and fitting.

The morning of the memorial, we were preparing to make our way to the playhouse, which is just ten minutes away from our home, when the task before me started to swell toward explosion. The fact that a memorial for my mother was about to happen meant that she had died. It all felt surreal. And impossible. She was only seventy-four. I was only fifty-two. It dawned on me that I'd lost both of my parents. I was a grown woman—already a grandparent—and yet, an orphan. I pictured myself swimming in the middle of the ocean, endless miles in every direction, no sign of the shore. Waves crashed around me. Water slammed into my eyes, ears, nose. I struggled to catch my breath. My

arms outstretched, trying to find one of their hands—grasping for stability, comfort, safety. But this time, I was all alone.

At the playhouse, David, Yvette, Howie, and I were stashed away in the sound booth at the rear of the theater, safely out of reach of the hundreds of people who arrived to honor Mom and say goodbye. It felt untenable to receive them all and far too difficult in that moment to simultaneously steady my grief alongside anyone else's. We stayed tucked away until just before the service began.

The theater was dark when we emerged to take our seats. I moved very slowly and deliberately and tried to maintain my composure. Seeing our big, beautiful family filling the front row—all of the kids and, of course, Carl—nearly unglued me. But I managed to sit there, like a well-trained theater patron, with my full attention on the stage.

And then, it was my turn to speak.

The podium felt enormous. It dwarfed me in size as I stood behind it, almost childlike. I was grateful that the lights completely blinded me to the audience. I had no sense of who was there and who was not. I could not see facial expressions or reactions, and owing to the intensified beating of my heart, I couldn't hear anything beyond the sound of my own voice reverberating between my ears.

It was happening.

As the words scattered before me on the page and marched back into position, somehow I spoke:

First . . . First let me say that while my left brain has known for some time that we might have to face this moment, and though through my Facebook tribute, I have been in some ways eulogizing my sweet mom for close to a year, I stand before you today with my heart crushed into countless pieces. Wholly unprepared. Bruised and broken. Obliterated by the enormity of this world, and this life, without my spectacular, beautiful, perfect mom in it.

Thank you, each of you, for being here to honor her and to support all of us. The kindness you have shown is astounding.

Ours is a story of unfathomable loss. And one, too, of astonishing love. My dad once wrote me a letter in which he hoped for me that life's highs would be so

exhilarating as to make the lows less devastating. He acknowledged that fragile balance then. Before he could know what would follow.

I started my tribute to my mom as a daily affirmation, a mantra for life and for living, hoping that it would channel love and support to her from far and wide, from camp friends and old boyfriends to bowling teammates, former students, and complete strangers; that it would fortify her, strengthen her resolve, remind her of just how many people she impacted. Make her smile, marvel, laugh, covet, cry. She looked forward to each day's post with an energy and interest I didn't quite expect. Each morning, she took to refreshing her browser to see if it was up, knowing that I would post first thing upon waking: a way I had of setting my intentions for the day. She let it all sink in. She absorbed all the love and pressed forward with remarkable focus and confidence.

I began to think of the project as a love letter to my mom, and unlike a eulogy, one that she could ponder and process as a still vibrant woman, so very much full of life. Along the way, I discovered things about her that I didn't know and, maybe most movingly, things I didn't even realize I thought or felt about her. I was awed by her beauty and stunned by her poise. It is an extraordinary experience to have the opportunity to fall in love with a parent—as an adult, and wholly anew; to see her as a fully realized, multidimensional person who played many roles in her life and who was also someone and something other than Mom. And in this way, I know I see her more clearly and understand her far better than ever before.

I would be lying if I told you there wasn't a part of me that believed that the sheer force of my love and devotion might somehow, some way, realign the universe so that she and we all could be spared the pain of this diagnosis and this particular ending.

A year of magical thinking. Surely there was a chance.

But alas.

And so, I've decided to share this final post here, today, and aloud:

1.15.19 *I love you, Mom*

I hope you are watching, alongside some of our favorite and cherished people and that they are holding you very tight. I hope that reunion we've all anticipated was so very sweet.

I hope you see—and are maybe even a little giddy—that we are in

the Westport Country Playhouse—the ultimate venue to pay tribute to your lifetime passion for the theater. [And I hope you are happy that I won't be singing.]

I hope you know you have been the greatest teacher, the biggest supporter, the very best cheerleader. Quietly laying the foundation, always showing us the way. Though you suffered such shocking and staggering loss twice in your young life, you found a path forward and you allowed yourself to love deeply and to be loved. This is perhaps the greatest trait you have instilled in me and in David, my magnificent brother, a gentle giant of a human. I so wish I could shield him from this pain.

I hope you are certain that we will take care of your Carl, OUR Carl, and that we will be forever grateful for the limitless, selfless, simply gorgeous way he loved you and for the gift of your time together.

I hope you NOW realize that you underestimated one critical thing. You have made SUCH a mark on this world. Your gentle imprint is in every cell of who we are. And extends to every person you've encountered.

I hope you remember that there will never be a moment of any day that I will not feel lucky that you were mine.

i love you, mom—july 12, 2019

Through the looking glass. On the calendar, it was six months ago today that we said goodbye. Half a year? But time isn't behaving normally. It's standing still. Then moving alarmingly fast. Then barely lurching forward in imperceptible increments. I look for you always—in the sky, in the breeze, in the glimmers of light and the shadows of the trees. In the swan who seems to be keeping watch just outside my window. You are so close; nearby. But also just out of reach.

In your honor, last night we went to see Pippin, *one of our favorites and yours. I knew that I would find you there, in every lyric, in every melody, and then unexpectedly, even in the firefly that settled itself by us. And stayed. I felt you sitting by my side, holding my hand and my heart in the dark theater—as you have countless times. This time, the magic and the music disguising the torrent of tears.*

Even in real moments of joy, which manage to exist, this missing is sometimes paralyzing. Quiet and just below the surface. Overwhelming, still. And surely, always. I struggle to make peace, if not sense, of just how this could be. And I keep looking.

i love you, mom—january 12, 2021

I feel a bit like I've walked into a confessional (which, admittedly, would be very odd): "It's been forever since my last post . . ."

And yet, milestones provide some oft-needed punctuation in the interminable and convoluted run-on paragraphs of 2020. It feels like time to share.

I discovered some additional images from a 1965 photo shoot and was so struck by these outtakes—representing those ephemeral moments in between and so beautifully illustrating how revealing those moments are. In this case, not just a photo of a captivating young woman for her engagement announcement but of the combination of excitement and perhaps even trepidation about this new phase of life on which she was embarking, of her natural introspection, playfulness/levity, and also, just pure sweetness. I can see so much more about who she was—at the tender age of twenty-one—and the woman she would evolve into. Not to mention the extraordinary mother she would soon become. It's all there, in the in-between.

As a photographer, I'd say I'm very aware of the in-between, but compiling this series was so poignant and also a subtle reminder that things are rarely just as they seem—on social media especially. These days, no doubt, everyone has their own, mostly private, version of struggle or suffering playing out just off stage. In the quiet.

Impossibly, it's been two years since I've been able to look into her big, beautiful brown eyes and see or feel that calm, comfort, and warmth reflected back at me. Seven-hundred-and-thirty days since I've been parented, encouraged and supported in that particular and unique way—the way that shaped so much of who I am. And I've needed it more than ever. The hole created by her absence is magnetic and gaping. I try, and sometimes fail, not to fall in.

Time during this past year has been largely suspended—with the world locked into a COVID-induced Never Never Land—where life as we knew it has been replaced by one soaked in anxiety and fear, where isolation has become a throughline and grief—at the micro and macro level—is heavy and rampant. The large-scale and excruciating losses we've seen as a society weigh on us every day and

are so often overwhelming, we can be distracted—momentarily—from our own daily losses. Yet without the typical ebb, flow, and movement of life, I'm afraid my personal grief has compounded. The silver linings, love and joy—of quality family time together with our incredible kids and enchanting new (grand)babies—are real and felt deeply. I am ever grateful; these gifts have helped keep me afloat. But in those fragile moments just before sleep, or during bouts of insomnia in the darkest part of the night, the electrical surge of the missing pulses through my heart and my body. Tears easily and readily flowing, still and always.

The amazing community that formed around my mom during her illness offered kindness and caring in a way I will never forget. And the legacy and muscle memory of my daily tribute to her keeps her presence close by.

I remember her every hour of every day. And today, I hope you will, too.

looking forward, looking back

A couple of years ago, I went to a gala celebration for my alma mater, Barnard College and Columbia University. In addition to being a fundraiser, the event honored my dear friend and college classmate Maryam Banikarim and her husband, Andrew, for their countless and continued contributions to the school.

While there, I got reacquainted with another college friend, Brandi Prescott. Our reunion, not surprisingly, led me down a photographic rabbit hole in search of some portraits of Maryam and Brandi that I'd taken on Westport's Old Mill Beach back in 1985. Along the way, I discovered this image of my mom rubbing up against other photos in slick plastic sleeves in the same binder. I have no idea how I could have missed it all these years, but alas, there it was.

I was immediately and instantly transfixed. Mesmerized. *Obsessed* isn't a strong enough word. Ironically, but surely not accidentally, as I began to feel that writing this book was beginning to conclude, this image rose to the surface. It beautifully ties a bow around the essence of what I think I've been trying to convey.

This is my mom. Age twenty-two. Startlingly beautiful, rivetingly innocent. Present. Laying in a messy bed in a simple, understated white nightgown on her honeymoon. Possibly posing for a portrait taken by her brand-new husband, my soon-to-be dad, in a very mid-century modern-looking Puerto Rican hotel room in August 1965. Putting aside the stunningly gorgeous and impressive composition of the photograph, it's impossible not to feel invited into this incredibly personal and intimate moment and, especially given my recent loss, to never want to leave.

Every time I look at the picture, I wonder more, what was going through her mind? Had they just arrived in Puerto Rico, or was this the final day of their getaway? Were they about to head back to New York? Did they lay in bed talking about the wedding for hours? Or maybe about the future about

to unfold? Were they already wanting to get pregnant? Was Mom missing her father and distracted by his absence at this significant and emotion-filled time of life? Was she relieved to be able to move into a new apartment with her new husband? Was she maybe a bit nervous, too? All these thoughts and countless more swirl around my brain—the curiosity and the closeness.

Is this photograph my proof? On some important levels, yes, it is. This newly discovered treasure opened a window into this precious moment and exclaimed, "This happened!" She was there. He was there, too, and took this picture, adoringly, of his new bride. They were together like this. My parents. So very young and so very much in love. Marking the moment for eternity.

It's also a very welcome starting place to think about and begin to understand what lies beneath and around the photo's borders. A query to dig deeper and learn more. To illuminate their beings. To keep the light.

photographs

I have all the pictures. The ones that are in the now dusty Kodak carousel wheel. The ones in the peel-back sticky magnetic-page albums. The square snapshots with the aging white borders. The shiny prints. The matte prints. The ones from which I cut away all the negative space so as not to waste valuable inches on the scrapbook page. I have the ones I acquired when Mom cleaned out a closet or when a stray box was recovered in an old office. And more recently, I have scans and scans of slides in plastic binder pages. Of course, I now have all the digital images, too. Downloaded from cameras. Uploaded from iPhones. Emailed and texted and Dropboxed and file-shared. All of them. I hold onto them all with the tightest of grips, afraid to let go, and at the same time with the tenderest, most loving caress, gently brushing on the outer edges of those moments now passed.

For a time, I had organized prints by category, by trip, or chronologically. These were filed away in white envelopes in whimsically patterned photo boxes from the now-defunct Light Impressions catalog that I used to love. Photographs *and* organization? Double bliss. But eventually, there were just too many of those boxes. Their mismatched colors and patterns set me on edge. I managed to purge the images that weren't worth saving and consolidated the rest into larger boxes marked simply as "PHOTOS" or "MEMORABILIA." This was quite off-brand for me. I stopped worrying about the commingling of trips and times, of people and places. I actually leaned into the disarray.

Just yesterday, I came to a realization about the heretofore unrecognized method behind that madness: It felt good. Having all of those moments swimming around together—face-to-face, back to back, completely nonchronological and disorganized and messy—felt like the perfect mirror to my memory all of a sudden. The free association between them felt unbounded and unconfined. There was no telling what memory or which image would

come to mind and when. The timeline of their creation no longer mattered. Instead, they floated around as if suspended in a transparent, viscous fluid, organically shifting, moving, and transposing until my attention stumbled upon one and then maybe another, plucking them back into consciousness.

And then, for a fleeting moment, they got to live again.

afterword

In a startling twist of fate, my Auntie Ann died on November 6, 2021, after an approximately one-year battle with pancreatic cancer. She was eighty-one years old.

It's hard to fathom losing her to the same treacherous disease that took my mother, but sometimes their parallel fates feel oddly salient. Because of the complexities surrounding the accident many years before, instead of being a steadfast and critical support for me or David or for Mom during her own illness, Ann was largely absent during that fight. She'd occasionally ask how Mom was doing or whether the treatment she was undergoing had changed the course of the disease, but she stayed removed, even antiseptic. She remained very deliberately on the outside behind a thick, impermeable barrier. On the other side of that barrier, Mom was stoically battling for her life.

The week before Mom died, Ann asked if she might come with me to Deep River to visit her. Perhaps she sensed the end was near? Perhaps she felt that her absence all year long was somehow noticeably egregious or just unkind? Or maybe she did it for me—knowing how important it was for me to feel supported and seen, for her to acknowledge the enormous loss I was about to endure. I'll never know why. But having her show even that small amount of interest was something, and I held on tight to it.

The night before Mom's memorial, Ann delivered two letters to my home. The first was for me and David, in which she explained that she would not be able to come to the memorial after all—that it should be about Mom and not about her and that it was all too much for her to bear. In so doing, of course, she made it all about her.

In the second letter, she requested that Mom's dearest friend, Harriet Selverstone, read some words Ann had written and wanted to share. Harriet did exactly as asked, but I have no memory of what she expressed. Ann's absence spoke far more loudly than any of her words.

The next year, Auntie Ann called to tell me of her diagnosis: "How can

lightning strike us again?" She revealed that she had pancreatic cancer, and from that moment on—while we were connected almost daily about the progress of her disease, the medical intervention, the possibility of various experimental treatments she might pursue—she nevertheless talked to me *as if* I had no exposure to or experience with the disease, *as if* my mother had not just recently died of the very same thing. *My mother.* Not a stranger. Not a friend of a friend. And yet, she behaved with a mystifying obliviousness to that undeniable and recent connection and to the weight of my loss. This was all new and all about her.

Oddly, even when she momentarily broke through that facade to ask me for some help in connecting her to the Lustgarten Foundation so that she could ask a question about a new treatment she wanted to investigate, as soon as I provided the contact and made the introduction, it was *as if* any memory of that connection just disappeared. Again.

Ann had an uncanny protective mechanism that prevented these truths from intertwining. They necessarily had to keep their distance. As hurtful and as painful as this often felt, and as hard as it was to stomach, I did my best not to judge her—and to understand that, for better or worse, it was what she needed, psychologically, to survive.

During the last weeks and months of her life, when a range of treatments from the typical to the absolutely bizarre had failed, Ann lost her drive to continue looking for an unproven solution. I was by her side that entire time, along with a few close friends and her loving boyfriend and companion, Paul Burger. Even in the face of all the pain already suffered and the losses already endured, or perhaps because of it, I knew I was right where I needed to be.

Those weeks were heartbreaking in all the obvious ways, but also in some less obvious ones: It became clear that after all this time, so much between us would have to remain unsaid. There would never be a reconciliation about my dad or the accident. There would never be forgiveness. There would never be any acknowledgment that we had all been forced to suffer in silence with respect to my dad for all of these years. She had erased him and, along with that, forced me to fully and quite distressingly contain so many of the memories of him and of us and of our collective and shared life. I am still processing the

trauma from that behavior—how stunted I was by the silencing, by having such a critical part of my being rendered invisible.

The last weeks of Ann's life were strangely luminous. There was laughter and love. There was caring and concern and true interest flowing in both directions. There were moments where one could see peace setting in. And the possibility—which we both believed—that she would soon be reunited with Sid and the kids was palpable. She slept a lot. Often for days on end, drifting in and out for countless hours. At first she was often clearheaded and cogent, then only sometimes, and then decidedly not. On one of those last lingering days, as a heavy and melancholy sun was quietly setting over the Long Island Sound just outside her window, she appeared to be sound asleep. Almost inaudibly, her brother's name slipped through her chapped and colorless lips: "Michael." I sat on the edge of her bed in stunned silence. Tears cascaded down my face.

Both Ann's presence and absence in my life have been profound. I miss who she was to me; I grieve for how that had to change, which was mainly for her own self-preservation. But if I am honest, I also feel an astonishing relief to no longer feel silenced or censored by her presence, to be able to express the truth and the depth of the loss of my parents in a way that honors and memorializes them best, without fear of or hypersensitivity to her reaction to that truth.

Because I cared deeply for her, I don't regret that, for so long, I put an ongoing relationship with her ahead of my need or desire to talk about my dad. And yet, that part of me feels like I can breathe again, too.

Ann will always be such an important part of my story. This afterword feels like the most fitting way to pay tribute to her glowing and sometimes outsized role in my life. At the same time, I won't allow it to diminish in any way the legacy of my parents, who deserve to shine so bright, each on their own.

A couple of weeks after Ann died, when the permanence of her absence and the effect it would have on my life was still unprocessed, a memorial was held at the Museum of Contemporary Art in Westport. Though the COVID-19 pandemic was still a factor in large gatherings, a crowd of people—from fellow artists and former colleagues to recent and lifelong friends and closest family—came to honor her. These were the words I shared:

For those who don't know me, I am Stacy Waldman Bass, and Ann was my most treasured aunt, my father's beloved sister.

I am fortunate to come from strong women on both sides.

My maternal grandmother, Ruth—headstrong, eccentric, and passionate— my own spectacular mother, Jessica, gentle, ever warm, and wonderful (and who passed away a little less than three years ago from this same insidious cancer).

On my father's side, his and Ann's mother, Leah, was my north star. She was a tiny woman who had a giant effect on all she encountered. Her wisdom and counsel were touchstones for me, always.

And then, there was Ann. No doubt, we each have our own stories about how she touched or influenced our lives. And because of who she was, I expect you will find some of your *story in* mine.

Growing up, the Weiners and the Waldmans were intertwined. Inseparable. Though we lived in different states, visits were frequent and always happily anticipated. We traveled together, skied at Windham together, shared milestones and holidays together. We each had limitless devotion to our extended crew—as well as a deep gratitude for the great good fortune we all had.

Auntie Ann was at the center—always directing our next big adventure or coming up with an art project or excursion for the cousins. And though I had some consciousness then that she was also quite accomplished professionally, all of that fell away when we were together. She showed a singular and always enthusiastic focus on whatever we were doing. She was present before that was a thing to which we were told to seek out. She listened to you in a way I've rarely experienced otherwise. She made me feel heard and seen and, frankly, cherished. *It's impossible to overstate the enormity of the impact this had on my self-esteem, my self-confidence, and my aspirations.*

Auntie Ann was magnetic—not just charming or charismatic or enchanting (though she was those things, too). Magnetic—as in impossible to pull away from. Even in those early days, I can remember David and I begging our parents to be able to stay just a little longer—never wanting to break that spell. Always yearning to be in her orbit. We absolutely adored (and desperately miss) Darcy and Glenn—who were as close to us as siblings—but if I'm being earnest about those early days together, it was Auntie Ann's light shining brightest.

It takes no effort for me to conjure up her precise tone when she'd say, "Heyyy

afterword 237

Stayy," or to remember how special I felt when she'd call me by my middle name, Pamela—like a secret code that was a passkey directly into my heart.

For twenty-eight years, that connection was, well, as good as it gets. It was a lifeline and a life force that buoyed and centered my days. And nights.

And then. Everything changed. August 26, 1995.

For many years after the accident, that magnet was most often turned around—repelling instead of attracting, heartbreakingly directed elsewhere. And though it took both painful and masterful censoring, for us both, we did find our way back. Our common passions for art and photography helped; in what we liked to read or watch or experience; in our kids' challenges and successes, new milestones reached and new children (and grandchildren) born.

We never made it all the way back—but I guess it was as much as was possible.

Each of the remarkable women I mentioned endured tragic losses in their lives, and each modeled a level of their own version of grace, poise, and strength that can only be described as outsized and heroic.

But Auntie Ann's version was perhaps most remarkable of all. She and Uncle Sid started again. She planted the seeds of a new family with her adopted children Devin and Gregory, whom she adored. She lovingly molded and nurtured them with her signature devotion, thoughtfulness, and boundless care. Their lives will forever be better for it—the ultimate gift.

And in so doing, she taught us all what it looks like to fight for a life, to fight for your life even or especially when it doesn't turn out the way you may have dreamed, hoped, or planned. She taught us to let the light in—in every way you can, in the darkest days and every day.

It is this legacy—hers—and that of the strong women in my life—that I strive to live up to. And when I find myself feeling lucky or joyful or, yes, even over-flowing with gratitude—even in the face of what's been lost—I know I'm on the right path.

In the last months before Auntie Ann died, I was at the house almost daily. Oftentimes, she'd be sleeping, but sometimes my timing would be just right and we'd talk. She always wanted a report on all of the kids and what was happening with each of them, delighting in photos from Michael's birthday celebration in San Francisco, Emily's game day in Ann Arbor, and most especially the pictures of our granddaughters and our then-brand-new grandson, Jackson. Maybe because

she never got to meet him, she was especially fascinated by Jackson. I can still hear her say, "Isn't that just the most beautiful thing . . . ?"

When we couldn't speak, I'd sometimes send her a text—not knowing if she'd ever see it, much less reply. On October 18, I texted her a few verses from the musical Wicked, *which had been running through my head as I sat by her bedside, quietly rubbing her feet or holding her hand:*

> *I've heard it said*
> *That people come into our lives for a reason*
> *Bringing something we must learn*
> *And we are led*
> *To those who help us most to grow*
> *If we let them*
> *And we help them in return*
> *Well, I don't know if I believe that's true*
> *But I know I'm who I am today*
> *Because I knew you*
>
> *It well may be*
> *That we will never meet again*
> *In this lifetime*
> *So let me say before we part*
> *So much of me*
> *Is made of what I learned from you*
> *You'll be with me*
> *Like a handprint on my heart . . .*

And to my surprise, the next morning she replied, in what was really our last truly coherent communication, which is especially affecting. She wrote,

> *Some for a reason,*
> *Some for a season.*
> *Some forever.*
> *You are a forever of mine.*

Mine, too, Auntie Ann. Mine, too.

acknowledgments

Perhaps, like me, you are reading this before you've even begun reading the book. I look forward to that additional glimpse into an author's world and inevitably find myself moved by the generous expression of gratitude. It's tempting to think that a creative work springs up and out, fully formed . . . but we all know that is rare. And surely, that was not the case here. This labor of love—and loss—grew into its current incarnation with the guidance and support of many, and it's my honor to acknowledge them here.

First, a huge thank you to all my friends; I am so lucky to have gathered a truly treasured collection of outstanding people around me in all ways and in every way that matters. From early readings of this manuscript to countless and hours-long lush and lingering conversations to having a heroic level of interest and enthusiasm in me and in this work, I am so grateful for each of you in my life and in my corner. And on the subject of friends, it feels especially important to acknowledge Harriet and Bob Selverstone. Your effusive, generous, and devoted friendship with my parents was one of a kind, and you graciously extended it to me and David and our families. We are so lucky to know and love you.

While it's been many years since I have been "in therapy" on the regular, I have to salute my once-and-forever therapist, the lovely and amazing Susan Juda. Thank you for your warmth. For every insight. For agreeing to double and triple sessions. And even acquiescing to a session/walk around the Central Park Reservoir. Thank you for helping me to pick up the pieces and to reassemble and stabilize a complex and ever-changing puzzle.

And though it took me almost thirty years post-accident to find EMDR trauma therapy (with thanks to the exquisite Amy Goldberg), I am ever grateful to Meaghan Warnock for unearthing connections that have been critically beneficial. There is no doubt that this work, in combination with my writing, proved to be the secret sauce to much comfort and revelation.

Thank you to the singular and shining Dani Shapiro for showing us all how it's done, for modeling how to give voice and clarity to raw emotion,

240 acknowledgments

and for elevating the beauty in the everyday. I am so grateful for your writing, your wisdom, and each of the wonderful women who assembled at your 2021 workshop at White Hart. Though we only spent a few days together, I feel like I can remember every minute and am grateful for the continued inspiration, camaraderie, and connection.

Thank you, too, to the ebullient Katie Bannon and our writing crew for helping me to create an intentional practice of my writing; it has made every difference.

Thank you to Jessica Almon Galland for your kindness and thoughtful recommendations that led me to editor Katie Gee Salisbury, who, even while on tour promoting her own magnificent book, managed to make the time to challenge me to resculpt *Lightkeeper* in all the best ways. I am so grateful for your guidance and counsel.

A huge thank you to the outstanding teams at Radius Book Group and Simon & Schuster. Mark, Julia, Evan, Danny, Pete, Kristen, Alvaro . . . thank you for all your efforts in service of making *Lightkeeper* the best it can be. And to the lovely and amazing Kim Dower, a.k.a. Kim from LA, huge gratitude for all your efforts in helping this debut shine bright.

It feels important to acknowledge the Westport Library, which has been part of my life since I was only four years old. From wide-eyed patron back then to development chair, board president, BOOKED *for the evening* cofounder and everything in between, my connection to and philanthropic focus on the library has been perpetually enriching. I am so grateful to all the staff, directors, cochairs, committee members, presenters, and BOOKED honorees for sharing your gifts with me. They are at once humbling and inspiring.

With my whole heart, I am grateful for my first family and have unwavering love and gratitude for my brother, David. Though we are in many ways very different, the depth of our immutable bond and the breadth of our shared experience fortifies me every day. It's still hard to comprehend that it's just us left, and I am holding onto that (and him) with all my might. Thank you, too, to my sister-in-law, Yvette. I am so grateful for our (still and always) evolving friendship. I love you.

It is my fervent hope that what I have shared here will resonate immensely

acknowledgments

with all our kids and grandkids (and ultimately with those still to come!), as well as with my nieces and nephew. An opportunity to have a deeper understanding of one's parents and grandparents is oftentimes elusive. I hope this offers illumination, both simply and profoundly. Ilysa, Alex, Avery and Jackson, Benjamin, Kylie, Evyn and Brooks: I love you all and feel lucky, every day, to get to share this one, big and beautiful life with you. Rachel, Jacob, and Ava: I love you and look forward to watching you take on the world with your charms. (All of) Your grandparents are so proud. And thanks to Carl, with gratitude, recognition, and enormous respect for the magnificent way you loved my mom each and every day you shared. A very special thank you, too, to sweet Nica Goldstein for your captivating curiosity and radiant kindness.

To Michael and Emily, there is no perfect or even adequate way to thank you for every day that I have been lucky, honored, and blessed to be your mom. I couldn't have done this—or most anything—without your sometimes quiet but nonetheless constant encouragement. There is nothing I can't accomplish with you cheering me on. And I hope you believe the inverse is true as well. You carry with you the significance of my losses in a different way—in your names, in your DNA, as your legacy. Though that may seem heavy at times, I hope you know and feel it is also the greatest gift. You carry that weight with such gorgeous grace and gravitas. I am awed and amazed by you both. I love you.

And finally. Howie: my love, my life, my dream. I often use this refrain, and it remains ever true. I used to think you saved me, but I have recently realized you did even more: You made it possible for me to save myself. I know it has been incredibly difficult to watch me suffer and struggle to get my feet back underneath me only to stumble time and again. And yet. You never, literally never, wavered in your resolve to stand by me through all of it—with open arms and the biggest heart. You gave me and my grief the freedom to move and change as needed. Without judgment or impatience. You have emboldened and celebrated each one of my creative endeavors with unbridled confidence and enthusiasm. You are everything I need, just when I need it. Truly. Madly. Deeply. Thank you. I love you.